DRIP.DOT.SWIRL.

94 incredible patterns for design and illustration

dvd includes editable vector files, swatch libraries and tutorials

VON GLITSCHKA

HOW BOOKS
Cincinnati, Ohio
www.howdesign.com

ABOUT THE AUTHOR

Von Glitschka has worked in the communication arts industry for over twenty years. He now refers to himself as an illustrative designer. In 2002, he started Glitschka Studios, a multidisciplinary creative firm (www.glitschka.com).

His work reflects the symbiotic relationship between design and illustration; he acts as a hired gun for both in-house art departments and medium to large creative agencies working on projects for such clients as Microsoft, Adobe, Pepsi, The Rock and Roll Hall of Fame, Major League Baseball, Hasbro, Bandai, Merck, Allstate, Disney, Lifetime Television and HGTV.

His exuberant graphics have garnered numerous design and illustration awards and have appeared in such publications as *Communication Arts*, *Print*, *Society of Illustrators*, *Graphis*, *American Illustration*, and *LogoLounge* volumes II, III, IV and V.

Von also teaches advanced digital illustration at Chemeketa Community College in Salem, Oregon, and operates the website www.illustrationclass.com where visitors can download free tutorials documenting his illustrative design creative process on a variety of diverse project types.

He often speaks and judges at design events and competitions nationwide.

All the text in this book was tweaked and polished by Maria Gudaitis. Thank you, Maria! http://www.mariagudaitis.com.

DEDICATION

To my mom and dad who have always encouraged me to pursue my creative dreams, even when the subject matter and style of my art left them scratching their heads.

I love you!

DRIP.DOT.SWIRL. Copyright © 2009 by Von Glitschka. Manufactured in China. All rights reserved. No other part of this book may be reproduced in any form or by any electronic or mechanical means including information storage and retrieval systems without permission in writing from the publisher, except by a reviewer, who may quote brief passages in a review. Published by HOW Books, an imprint of F+W Media, Inc., 4700 East Galbraith Road, Cincinnati, Ohio 45236. (800) 289-0963. First edition.

For more excellent books and resources for designers, visit www.howdesign.com.

13 12 11 10 09 5 4 3 2 1

Distributed in Canada by Fraser Direct, 100 Armstrong Avenue, Georgetown, Ontario, Canada L7G 5S4, Tel: (905) 877-4411. Distributed in the U.K. and Europe by David & Charles, Brunel House, Newton Abbot, Devon, TQ12 4PU, England, Tel: (+44) 1626-323200, Fax: (+44) 1626-323319, E-mail: postmaster@davidandcharles.co.uk. Distributed in Australia by Capricorn Link, P.O. Box 704, Windsor, NSW 2756 Australia, Tel: (02) 4577-3555.

Library of Congress Cataloging-in-Publication Data

Glitschka, Von.
 Drip.dot.swirl : 94 incredible patterns for design and illustration / Von Glitschka. -- 1st ed.
 p. cm.
 Includes bibliographical references and index.
 ISBN 978-1-60061-134-6 (hardcover with dvd : alk. paper)
 1. Repetitive patterns (Decorative arts) 2. Pattern books. I. Title.
 NK1570.G59 2009
 745.4--dc22 2008052311

Edited by Amy Schell
Designed by Grace Ring
Production coordinated by Greg Nock

TABLE OF CONTENTS

"TO UNDERSTAND IS TO PERCEIVE PATTERNS."
—Isaiah Berlin

Sometime around 1995, the wife of British mathematical physicist Sir Roger Penrose was grocery shopping and made a remarkable find. One of her husband's discoveries—a non-repeating pattern known as Penrose tiling—was imprinted on a roll of quilted Kleenex toilet paper.

The Oxford professor took legal action, perhaps the world's first and only lawsuit involving theoretical geometry and a bathroom product.

But why appropriate this arcane pattern?

Bathroom tissue bunched up where the quilting overlapped. Someone realized Penrose's design would produce a smoother roll. The suit was settled amicably, allowing Kleenex to continue using the pattern.

Penrose is also connected to another pattern master— M.C. Escher—who is connected to one of the ancient world's most glorious examples of pattern, the Alhambra, which is also connected to the author of this forward. I'll tie these together later, but meanwhile, let's meander a bit more.

"SEE THAT YOU MAKE [EVERYTHING]
ACCORDING TO THE PATTERN SHOWN YOU
ON THE MOUNTAIN."
—Exodus 25:40

Patterns are universal, yet often are subtle. They're found in stock market fluctuations, shark behavior, male baldness and grammar.

Designers and illustrators use patterns regularly. At times we hardly notice their ubiquitous cascade across our walls, screens, fabric and art.

This book has 94 patterns for your design projects. Von Glitschka has carefully designed each tile so they can be repeated across a page—or infinity—forming continuous designs.

Repeating tiles like those found in this book and DVD are properly called *tessellations*. The word emerged from the Latin *tessella*, "a small square of mosaic material."

Simply put, tessellations are tiles—shapes that interlock to cover space without gaps or overlaps. There are seventeen categories of tiling, based on symmetries in the pattern.

Bathroom tiles can be tessellations. Cobblestones, chessboards, and brick walls are tessellations. The freaky Escher poster on a college freshman's wall, with birds morphing into fish: tessellation.

I love finding patterns in culture, conversation and design. This fondness for context was likely from growing up "tri-culturally"—having a Lithuanian father and a Korean mother while living in the US. My sisters and I navigated an Amazon River of information. Beliefs and expectations flowed in from three streams. We were as the people of ancient Sumer, flourishing in Mesopotamia—the middle of the rivers.

Like the lattice tiles of this book, multiple expectations snaked across our lives in easy-to-ascend patterns. This fertile land produced young Roger Penroses: cultural researchers delving into the esoteric frameworks governing our universe.

Except there were no shared awards with Stephen Hawking, no knighthood from the Queen. Instead, we harvested academic and athletic awards. We learned to predict, observe, adapt, conform.

But this too is part of pattern—adherence to a norm. Even the word *pattern* hints at this. It derives from the French *patron* ("boss, proprietor, pattern"), from the Latin *patronus* ("model, lord, master"), back to the Proto-Indo-European root *pater* meaning "father."

Embedded deep in the word *pattern* is a sense of a governing authority.

"ART IS THE IMPOSING OF A PATTERN ON EX-
PERIENCE, AND OUR AESTHETIC ENJOYMENT
IS RECOGNITION OF THE PATTERN."
—Alfred North Whitehead

During my first year in college, we studied the people of the Mesopotamia. I dreaded plodding through cuneiform and early plows. Actually, the Sumerians were an interesting bunch: first in civilization, writing, arithmetic and the wheel.

These ancient overachievers created some of the earliest tessellated art: pottery and temple mosaics from around 4000 B.C. Geometric patterns predated writing by almost a millennium.

Despite their achievements, the Sumerians never discovered the concept of zero. However, they invented beer, for which civilization is thankful.

"THE SOUL IS ATTRACTED TO WELL-PROPORTIONED THINGS LIKE ITSELF."
—Abû Muhammad `Alî ibn Hazm

In the winter of 1987, a girl of nineteen left Belgium, a land that elevated the humble Sumerian beverage into an art form.

Backpackers all over Europe were fleeing to more fragrant climes. On the way to Morocco, she stayed in Grenada for a few days to visit the Alhambra.

The Moorish kings completed this pinnacle of Islamic architecture and art around 1350 A.D. Both a royal palace and a fortress, the Alhambra is adorned with a spectacular showcase of tile art and tessellation.

The Spanish captured Grenada from the Moors in 1492. Columbus was on hand as King Ferdinand and Queen Isabella strode through the gates, ascending a plateau to the luminous palace with thirteen towers.

The idealistic and fanciful young lady wandered the grounds for hours. She didn't know the architects and artisans who inlaid the mosaics were kindred spirits. These Moors lived in Spain, but were people of Arab and Moroccan-Berber descent.

Like her, they were tri-cultural. Mixed, complex, alien. Their genius came in synthesis, a ceramic flamenco of Arab, Atlas Mountain primitive and local Iberian flavors.

Despite room after room of dazzling tile, the beauty of the Alhambra relies greatly on restraint. Like the best of print or web design, fancy stuff is abutted by "white space": gardens, pools, plain walls.

The Alhambra's intricate mosaics display thirteen of the seventeen identified pattern types. It's rare to find so many tessellated variations in one location.

And this was before computers, before modeling software. Artists worked with mathematicians to declare in stone and tile the infinite nature of God. They stumbled upon secret things of universal—and I would say—divine order. Things that would be revealed eight centuries later in quantum physics and modern geometric theory.

Math, some say, is the science of patterns. Science and math both seek to unlock mysteries of this world's framework. Perhaps patterns hold keys into this cloud of unknowing, what the Bible calls the "hidden things of God."

"THE KNOWLEDGE OF WHICH GEOMETRY AIMS IS THE KNOWLEDGE OF THE ETERNAL."
—Plato

The human love of pattern reveals our vulnerability. We strain to embrace the web of cohesion holding the universe together. Math and science comfort us. Like pattern, they assert there is a code, a promise—that two plus two equals four, that there is cosmic continuity, that the world is interlocked.

Things exist we can't see. Some things we see are not what they appear to be. The universe goes down—and up—to deeper and higher levels.

From the microscopic to the cosmic, examples of beautiful patterns that testify to order and connection are found.

Duality is not an option: patterns must have at least two colors or elements. They must have a defined, regular shape. They must abut properly with one another.

The infinite and the finite. Grace and law, together. In stars, and in tiles.

Since this is a book on patterns, we delight in the invisible laws of beauty and order. But never forget: life bursts with capriciousness. Isn't freedom the basis both for existential terror and true creativity?

Even though we celebrate and crave it … we can transcend pattern.

> **"Family love is messy, clinging, and of an annoying and repetitive pattern, like bad wallpaper."**
> —Friedrich Nietzsche

We'll probably never again achieve the heights of tile design seen on the walls of the Alhambra. Innovations in theoretical pattern geometry reached a peak in the late 20th century. Writing and beer—discovered, but still being refined.

So much has been invented or revealed. However, as Nietzsche infers, we'll always have family love, and wallpaper. Decoration of our living (and working) spaces is as old as the plow. The material and digital worlds are replete with the glory of pattern.

Pattern—like beer and geometry and quilted toilet paper—will never become outdated. Pattern trends have their own patterns, which rise and ebb according to tastes, but return, cyclical like lunar tides, washing over and penetrating each successive layer of technology and civilization.

This is why you should never get rid of plaid pants.

> **"Happiness is the longing for repetition."**
> —Milan Kundera

I believe you came here and picked up this book because you seek happiness. Design happiness. You're looking for texture and accessories. Perhaps even a centerpiece. (Patterns can be the star for many projects.)

Most likely, though, you need flavor—but not as a mushroom or a meatball or even a mú (a Korean turnip). Not a single element. You need something evenly distributed through the dish, like specks of fiery pepper. Vines. Stripes. Grids. Filigrees.

With these patterns that Von has crafted, you have the ingredients to create your own Alhambra. A palace. A fortress. A refreshing garden for your ideas, with paradise inscribed on the walls. Towers seen from afar, eliciting sighs.

I know: we often work and play in the world of the mundane. PowerPoint slides. Annual reports. Discount coupons for tires.

No matter. Dare to sprinkle a little glory on the clay.

> **"There is repetition everywhere, and nothing is found only once in the world."**
> —Johann Wolfgang von Goethe

In the end, the longing for repetition must be fulfilled, the tiles must connect…even in a book foreword. So let's tie up loose ends and complete our seamless pattern.

Roger Penrose? His life intersected with that mind-blowing tessellation master M.C. Escher. Penrose provided mathematical constructs for some of the artist's most popular works, including the infinite staircase and ever-flowing waterfall.

Escher? The Alhambra helped ignite his lifelong passion for repeating tiles. Sketches Escher made in Grenada in 1936 served as source material for the next forty years. One visit, one event…repeating and impacting a lifetime.

The Sumerians? We're currently in conflict with some of their descendents, despite their having invented beer and arithmetic.

The young lady at the Alhambra, adorned in a patterned scarf, sketchpad in hand? Her early years reading design annuals and composing pretentious journal entries led to a career in arts and writing. The whole cultural mélange thing turned out to be a deep well, irrigating many metaphorical gardens. She still builds bridges over rivers, has an unreasonable fondness for water, and writes in the third person from time to time.

And you? You now have some tools and a whole book of digital patrons. Go invent beer or arithmetic. Inscribe beauty somewhere. But don't forget the reflecting pools and white space. Live in the midst of the rivers. Emboss infinity onto toilet paper.

> —**Maria Chong Gudaitis**
> www.mariagudaitis.com

INTRODUCTION

Part of the bonus set found on the DVD only.

The sole purpose of this book is to facilitate your own creativity. As you proceed, I encourage you to explore, experiment and push your own creative comfort zone.

DIVERSE

The creative arts community has a broad range of skill sets and design disciplines, each requiring their own unique approach to solve the task at hand. I kept this in mind as I created the illustrative patterns in this book. You'll find a diverse range of styles, themes and color options to help you achieve the design results you want in your own artistic pursuits.

CUSTOMIZABLE

All ninety-four patterns tile seamlessly so you can use them on any type of project. Each pattern is also easy to customize and adapt to your own projects. You can modify the colors, edit the vector shapes to simplify a pattern or even combine several patterns to create your own distinct look and feel. The creative possibilities are only limited by your imagination. (See the "How to Use Patterns" PDF files on the DVD.)

INSPIRING

This book also features ten industry professionals who have used patterns from the book in their own projects. See how they customized the patterns and put them to use in their own work.

Whether you're working on an identity system, poster design, illustration, publication layout, craft project or even an animation, you'll be sure to find a pattern that is appropriate for your specific needs.

—**Von Glitschka**

FUNKY FLORAL

Indigo blossoms float; delicate petals make a perfect boat.

▦ PATTERN COLOR SWATCHES

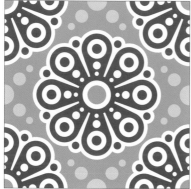

Funky Floral_p1

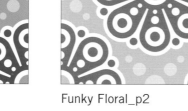

Funky Floral_p2

Funky Floral_p3

⊞ TILED PATTERN

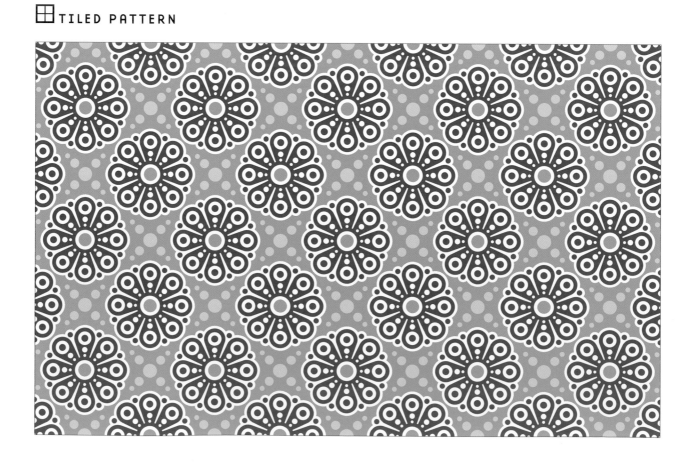

BOILING POINT

My stream of ideas flow, pooling into a wellspring of inspiration. I slowly heat them through exploration until a boiling point is reached and a new pattern floats to the surface.

▤ PATTERN COLOR SWATCHES

Boiling Point_p1

Boiling Point_p2

Boiling Point_p3

⊞ TILED PATTERN

LITE-BRITE

My mom would be vacuuming the living room floor, and all of a sudden I hear the painful rattling of plastic shards. Once more, her sturdy Hoover had consumed stray Lite-Brite pegs. The casualty of childhood art inspired this pattern.

⊟ PATTERN COLOR SWATCHES

Lite-Brite_p1

Lite-Brite_p2

Lite-Brite_p3

⊞ TILED PATTERN

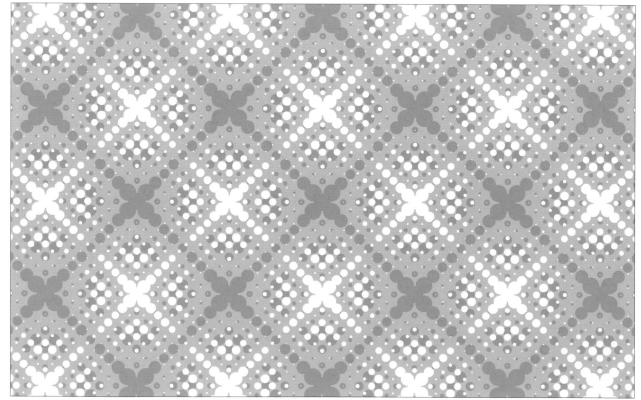
Pattern rotated 45°.

WROUGHT IRON

I have wrought many hours to fabricate precise vectors for your graphic enjoyment. (The word "wrought" isn't used enough in our vocabulary. I think it's time to change that.) What hath I wrought with this complex trellis? Is it good or wroughten?

⊟ PATTERN COLOR SWATCHES

Wrought Iron_p1

Wrought Iron_p1

Wrought Iron_p1

⊞ TILED PATTERN

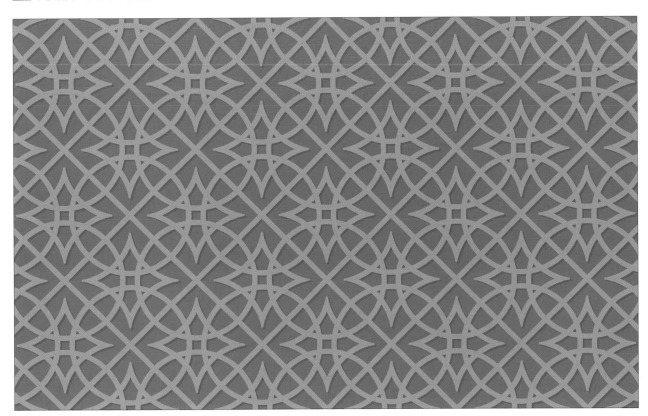

BONE HEAD

Born from death, the skull is an all-time favorite theme of artists—ecclesiastical, folk or street. Everyone with a cranium knows it's a cool, iconic image that's fun to draw.

▣ PATTERN COLOR SWATCHES

Bone Head_p1 Bone Head_p2 Bone Head_p3

▦ TILED PATTERN

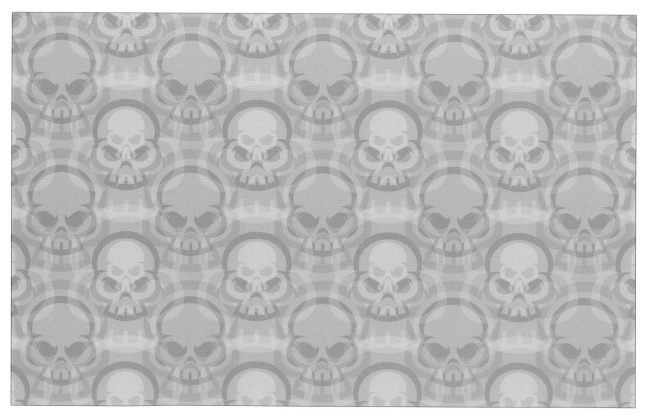

VINDALOO

Spicy fare from an admirer of Indian culture: a pattern infused with saffron and curry, cooked up in an unglazed terra cotta oven. It'll be the source of naan-stop inspiration.

▤ PATTERN COLOR SWATCHES

Vindaloo_p1

Vindaloo_p2

Vindaloo_p3

▦ TILED PATTERN

HIP TO BE SQUARE

Hip cats know that sometimes the best groove doesn't come from thinking outside the box. Embrace your inner square and enjoy this funky atomic age pattern.

⊟ PATTERN COLOR SWATCHES

Hip to Be Square_p1

Hip to Be Square_p2

Hip to Be Square_p3

⊞ TILED PATTERN

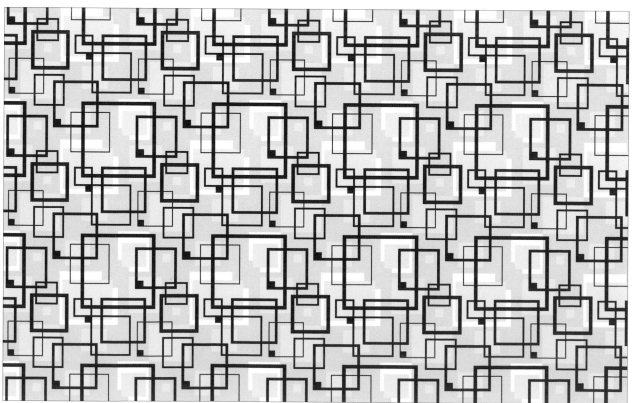

HYPER COIL

The temporal interweave of harmonic graphics.

⊟ PATTERN COLOR SWATCHES

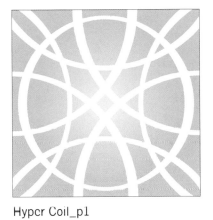
Hyper Coil_p1

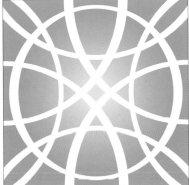
Hyper Coil_p2

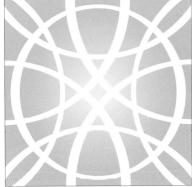
Hyper Coil_p3

⊞ TILED PATTERN

GRAPHIC BLOOM

In the fertile soil of your design, plant this foliate pattern and watch
beauty emerge.

▤ PATTERN COLOR SWATCHES

Graphic Bloom_p1

Graphic Bloom_p2

Graphic Bloom_p3

⊞ TILED PATTERN

FEATURED ARTIST

Brent Pelloquin

Designer & Illustrator
Louisiana, USA

www.prejeancreative.com

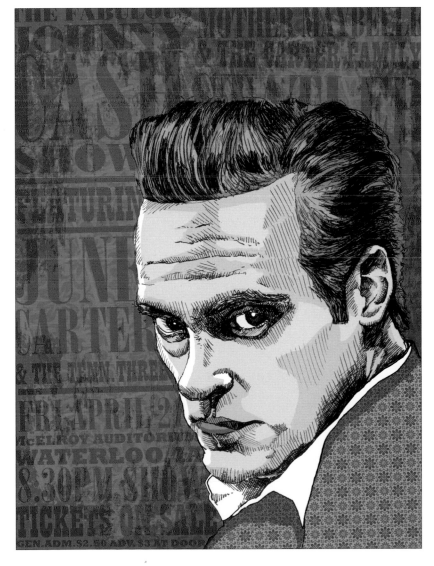

CASH 1968. Artwork created by Brent Pelloquin. Copyright © 2008.

DESCRIPTION

Graphic Bloom immediately made me think of my aunt's tacky 1960s wallpaper or a nice vintage shirt with snaps. One of those shirts that everyone thinks is horrible, but when worn by the right person, sets off a fashion craze. My inspiration here was Johnny Cash: one of those rare people who can wear whatever he wants and make it look cool. I decided to illustrate his big screen alter ego, Joaquin Phoenix.

I tiled the pattern, then alternated the color of some of the flowers to create a pattern within the pattern and give the shirt some contrast. Graphic Bloom was also used in the background texture to create the look of an old concert poster disintegrating on a wall.

—Brent Pelloquin

LEAF ME ALONE

This name demonstrates my love for all things punny! Don't worry, this was not accidental; I plant the whole thing.

⊟ PATTERN COLOR SWATCHES

Leaf Me Alone_p1

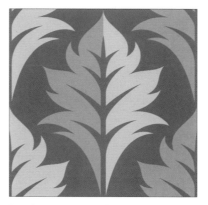

Leaf Me Alone_p2

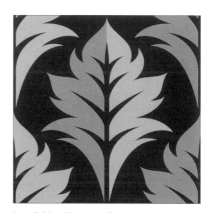

Leaf Me Alone_p3

⊞ TILED PATTERN

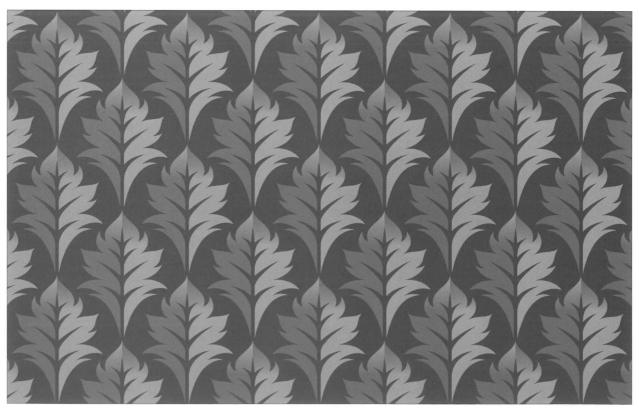

DOT MATRIX

Nothing is more sexy to a computer geek than the mechanical whine of a
dot matrix printer. Put away your PC or Mac and try out this pattern using
a Commodore 64.

⊟ PATTERN COLOR SWATCHES

Dot Matrix_p1 Dot Matrix_p2 Dot Matrix_p3

⊞ TILED PATTERN

ZULU NIGHT

As a parent, I love to develop the creativity of my children. I asked my daughter for help with this title. It had to include the word "Zulu." She said, "How about Zulu Night?" Perfect. It invoked the image of sunset over a sweltering landscape, joyful music by firelight. Thanks, Savannah!

▦ PATTERN COLOR SWATCHES

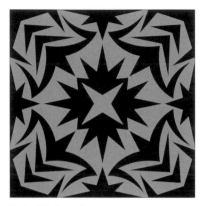 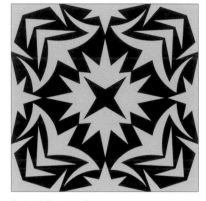 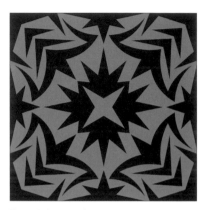

Zulu Night_p1 Zulu Night_p2 Zulu Night_p3

⊞ TILED PATTERN

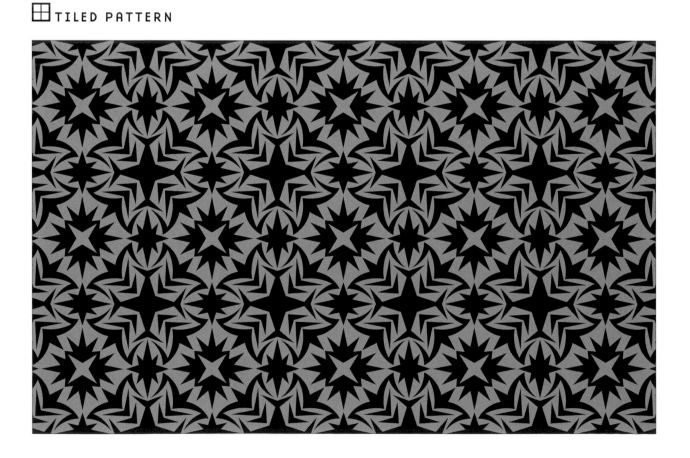

DRIP ZONE

It's said the world is made up of 70 percent water. So, naturally, your design should contain no less than 70 percent of this purified aquatic pattern.

⊟ PATTERN COLOR SWATCHES

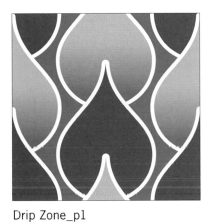 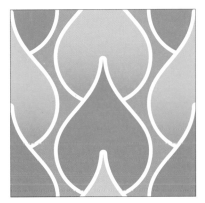 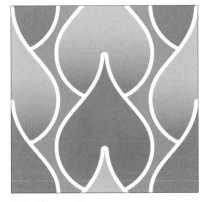

Drip Zone_p1 Drip Zone_p2 Drip Zone_p3

⊞ TILED PATTERN

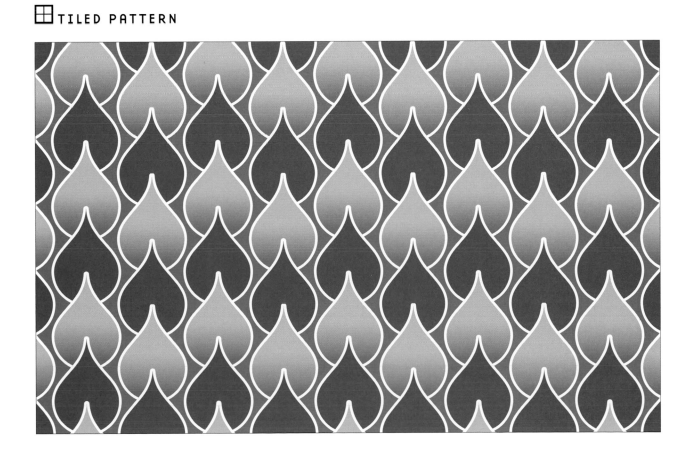

FLEUR-DE-SOL

Il est tout juste que un type comme moi dessine de jolies configurations
de fleur. (Translation: It's all right for a guy like me to draw pretty flower
patterns.) Does the French help this sound more manly, or do you think
I should have used Uzbek?

⊟ PATTERN COLOR SWATCHES

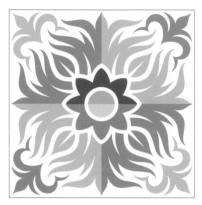

Fleur-De-Sol_p1

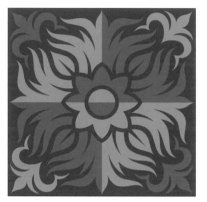

Fleur-De-Sol_p2

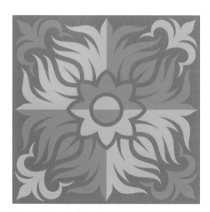

Fleur-De-Sol_p3

⊞ TILED PATTERN

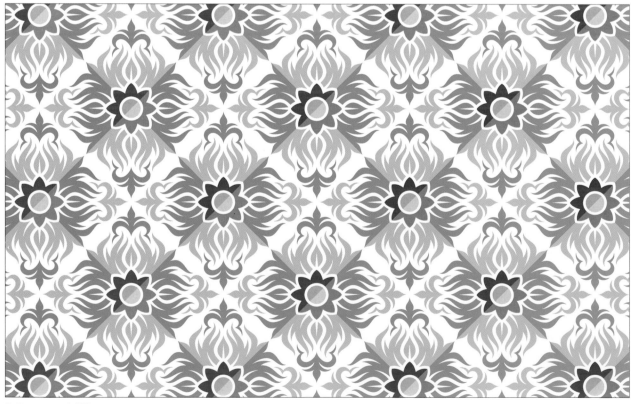

Pattern rotated 45°.

TUSCAN PATIO

Under a strong September sun I enjoy wine, fresh bread, fragrant olive oil and an epic view of the Italian countryside. Vineyards are ripe for harvest and wheat fields in the distance sway. The colors and impressions of Tuscany are sure to start a design renaissance in any heart.

⊟ PATTERN COLOR SWATCHES

Tuscan Patio_p1

Tuscan Patio_p2

Tuscan Patio_p3

⊞ TILED PATTERN

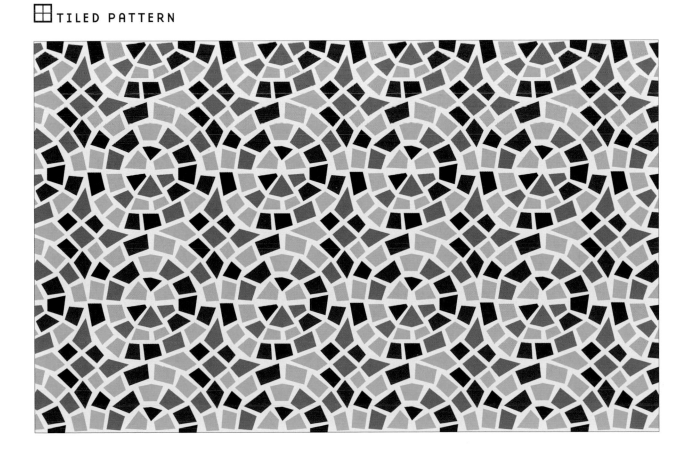

IRISH INTERLOCK

After a brief downpour, I followed a rainbow seeking a pot of gold. Mythical coinage eluded me, but I did capture a leprechaun. I refused to release him until he agreed to share his hidden treasures. Lucky for me, he was an expert at Illustrator—and he designed this emerald interlock for my book, assuring me I'd become a millionaire off the royalties.

⊟ PATTERN COLOR SWATCHES

Irish Interlock_p1

Irish Interlock_p2

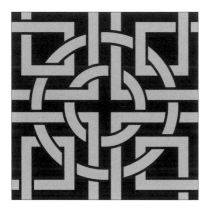

Irish Interlock_p3

⊞ TILED PATTERN

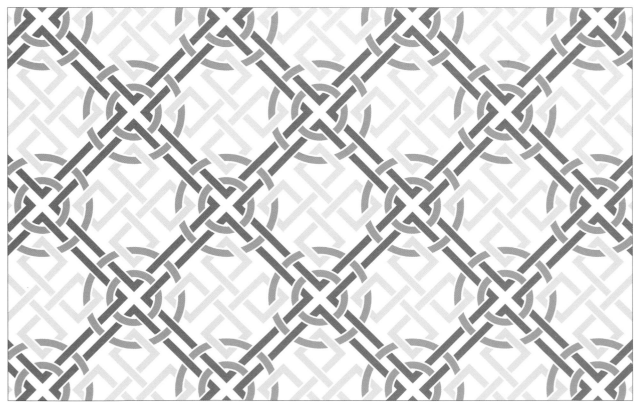

Pattern rotated 45°

MOLECULAR

Between bubbling beakers and Bunsen burners, in the midst of a mad design scientist's laboratory, this elemental compound was formed by splicing creativity and skill on the molecular level.

▥ PATTERN COLOR SWATCHES

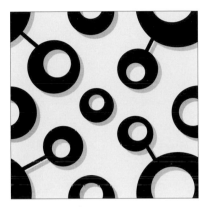 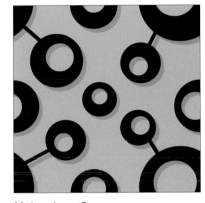

Molecular_p1 Molecular_p2 Molecular_p3

▦ TILED PATTERN

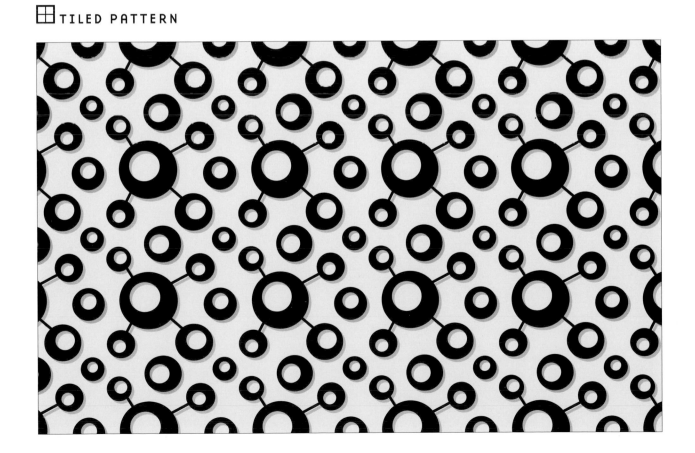

TURKISH DELIGHT

In *The Lion, the Witch and the Wardrobe* by C.S. Lewis, the White Witch tempts Edmund with "Turkish Delight." I hope this pattern, infused with the aura of bazaars, figs and strong coffee, will also tantalize your design senses.

 PATTERN COLOR SWATCHES

Turkish Delight_p1 Turkish Delight_p2 Turkish Delight_p3

⊞ TILED PATTERN

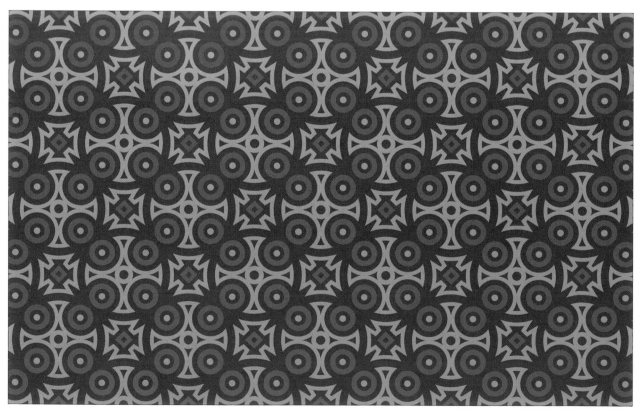

FEATURED ARTIST

Ty Mattson

Designer
California, USA

www.mattsoncreative.com

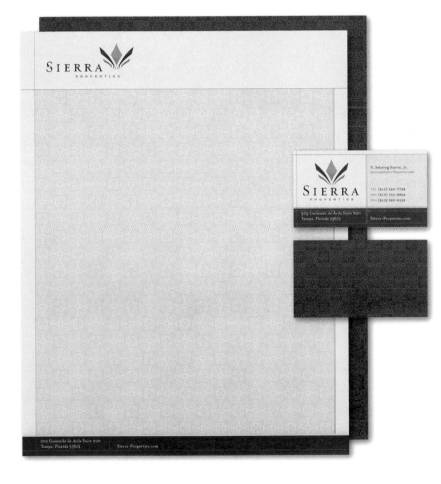

DESCRIPTION

I never get tired of designing stationery systems. They usually go hand-in-hand with the identity development process, and it seems like a logo is never fully complete until it's applied to letterhead, an envelope or a business card. More often than not, the stationery system is the first opportunity to explore the visual language—the color, pattern, texture, typography and photography—that will come to represent the brand across a variety of media. The challenge for me is to find an interesting and original balance of these elements and still convey the information that a letterhead or business card needs to communicate. I think the Sierra Properties stationery system is a good example of the different elements that comprise the visual language of a brand working together. Von's Turkish Delight pattern really added a great texture, but it doesn't overpower the other components. The overall effect is subtle and sophisticated.

—Ty Mattson

SIERRA PROPERTIES STATIONERY SYSTEM. Design created by Ty Mattson.
Copyright © 2008.

SPLOTCH

Technicolor amoeba? Blood splatter from a cartoon-world murder scene?
Wallpaper from the Den of Lovin' in Haight-Ashbury? Or all of the above?
I'll let you decide.

⊟ PATTERN COLOR SWATCHES

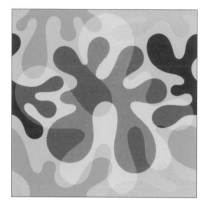

Splotch_p1 Splotch_p2 Splotch_p3

⊞ TILED PATTERN

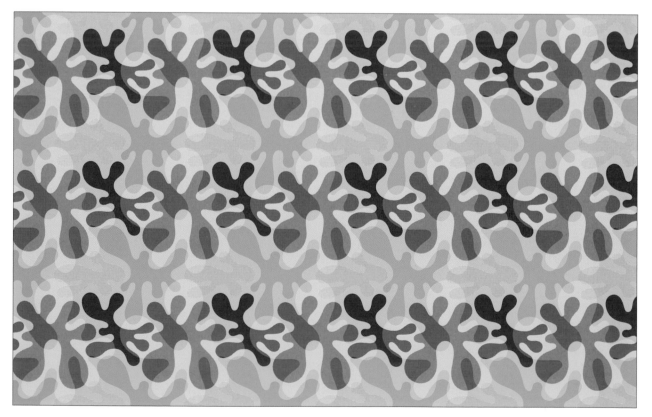

DIAMOND DISTRICT

Engage your audience with this pattern inspired by one of nature's most brilliant gems.

⊟ PATTERN COLOR SWATCHES

Diamond District_p1

Diamond District_p2

Diamond District_p3

⊞ TILED PATTERN

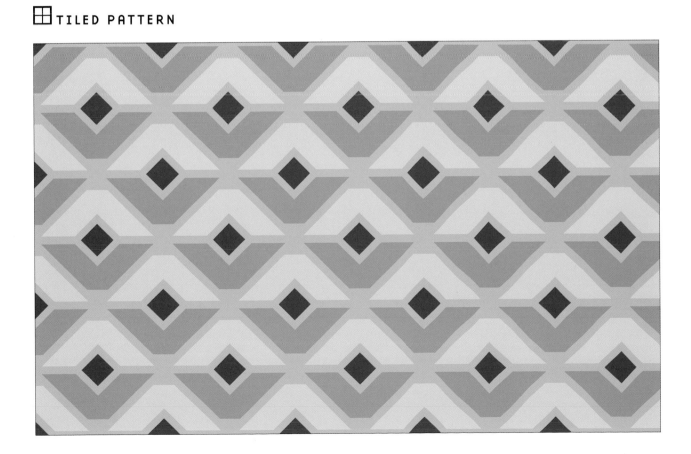

NOODLER

I tried to capture spaghetti on my flatbed scanner, but it didn't work. Instead, I'm serving up some vector pasta for your creative consumption. Slurp!

▤ PATTERN COLOR SWATCHES

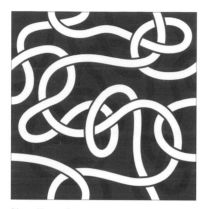

Noodler_p1

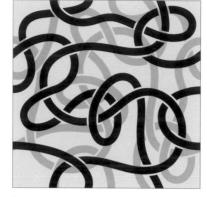

Noodler_p2

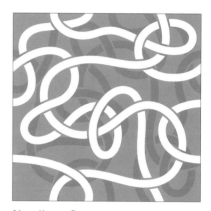

Noodler_p3

⊞ TILED PATTERN

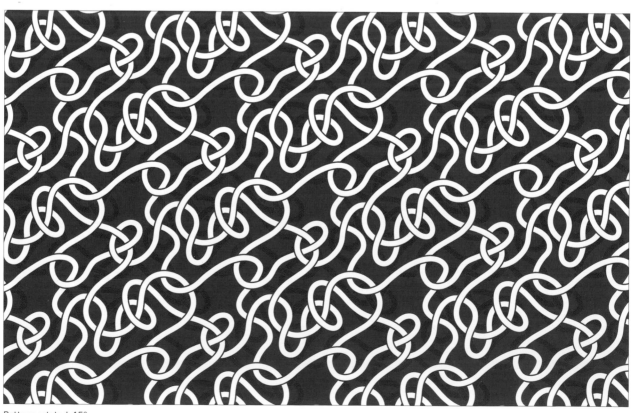

Pattern rotated 45°.

CARBONATED

Effortless ideas will bubble up from the fizzy goodness of this design.
Eat some Pop Rocks or swig a Coke—but not both!—to froth up
further inspiration.

 PATTERN COLOR SWATCHES

Carbonated_p1

Carbonated_p2

Carbonated_p3

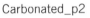 TILED PATTERN

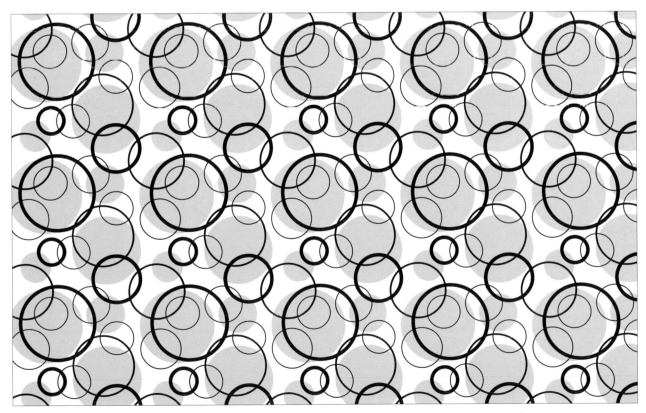

MEDIEVAL CHIC

A canticle from the castle… this William Morris-inspired motif will illuminate your manuscripts and illustrate projects ranging from serfs to surfs.

⊟ PATTERN COLOR SWATCHES

Medieval Chic_p1 Medieval Chic_p2 Medieval Chic_p3

⊞ TILED PATTERN

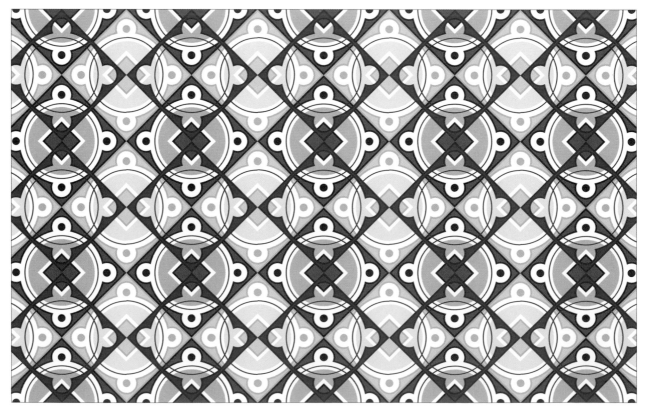

SLIPPED DISKS

Hypnotic disks spin like plates at a Chinese acrobat show.

⊟ PATTERN COLOR SWATCHES

Slipped Disks_p1

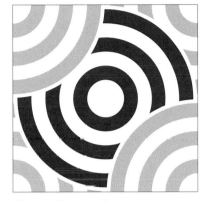

Slipped Disks_p2

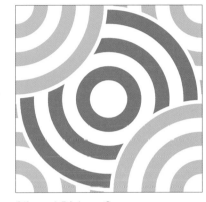

Slipped Disks_p3

⊞ TILED PATTERN

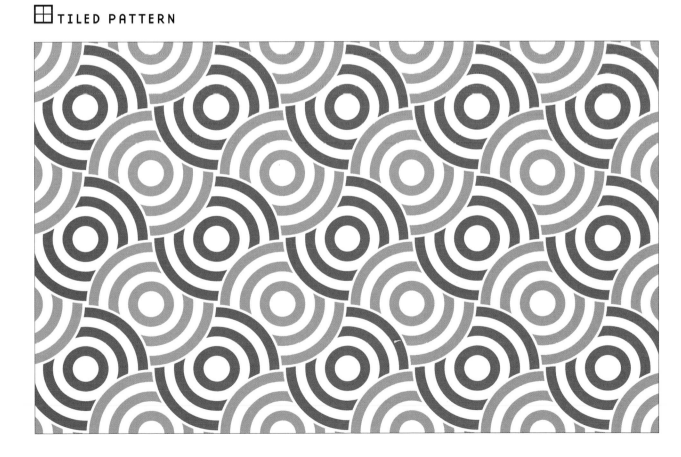

NETWORKING

Take a byte out of your workload with this well-connected digital inspiration.

▤ PATTERN COLOR SWATCHES

Networking_p1

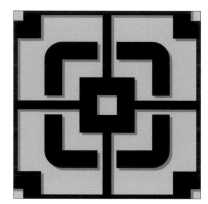
Networking_p2

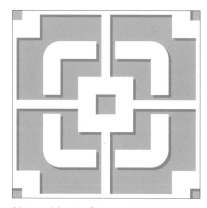
Networking_p3

⊞ TILED PATTERN

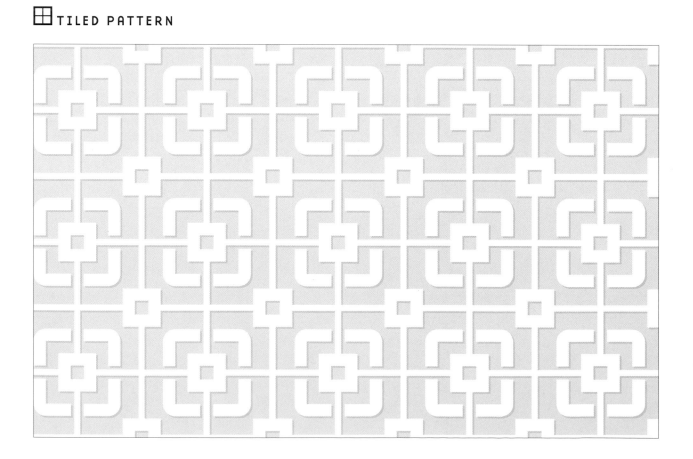

WANT A SWIRLY

He hobbled into class, hair dripping wet, shirt clinging to his thin frame, countenance downcast. He had just been introduced to his first day of high school. Along with learning quadratic equations, he would quickly master the art of evasion. As you can see, inspiration for patterns can come from anywhere.

▤ PATTERN COLOR SWATCHES

Want a Swirly_p1

Want a Swirly_p2

Want a Swirly_p3

⊞ TILED PATTERN

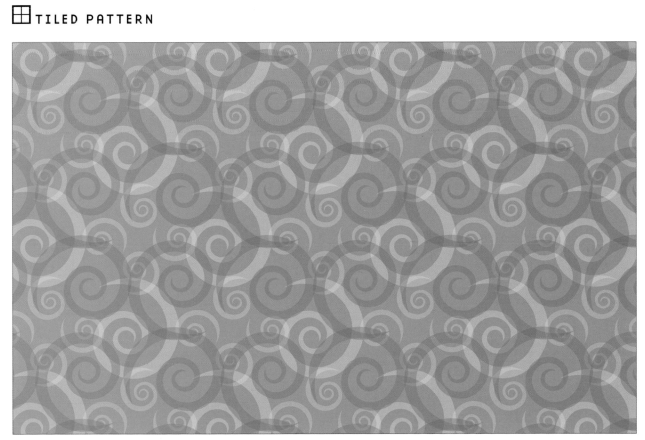

Pattern rotated 45°

HIVE MIND

I struggled to name this bee-licious pattern. Thankfully, my talented friend Ty suggested "Mind Hive," and I just switched the word order. Another not-so-helpful friend suggested "Greg Brady." Paul, I think it's time you got over that crush on Marcia.

⊟ PATTERN COLOR SWATCHES

Hive Mind_p1

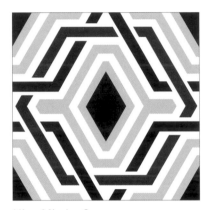

Hive Mind_p2

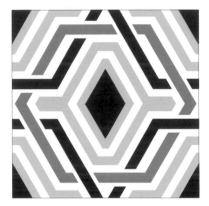

Hive Mind_p3

⊞ TILED PATTERN

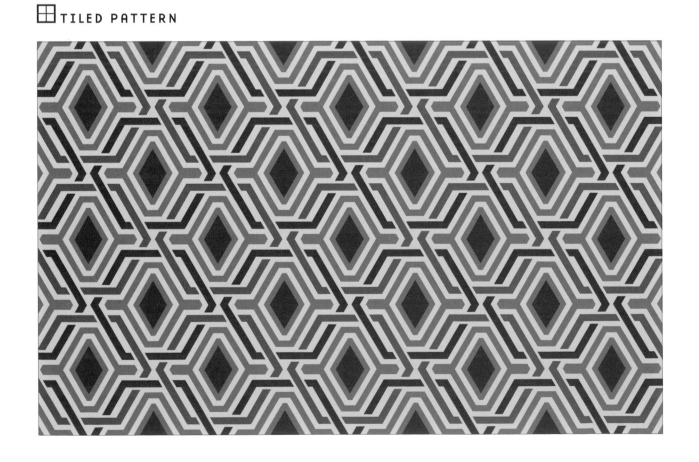

FEATURED ARTIST

Ward Jenkins

Illustrator
Oregon, USA

www.wardjenkins.com

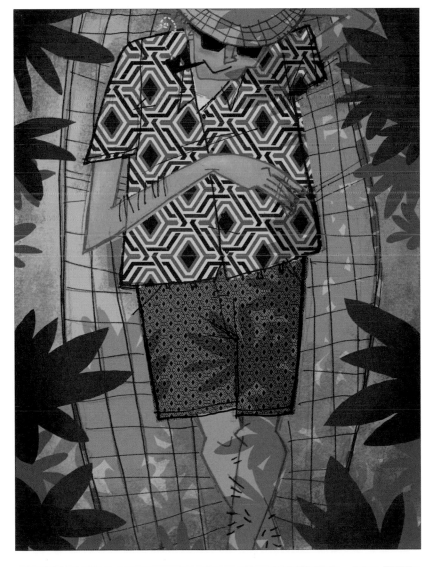

BACKYARD. Artwork created by Ward Jenkins. Copyright © 2008.

DESCRIPTION

Recently, my wife and I bought a hammock. I've often found myself swinging on the hammock, relaxing, thinking about nothing. One day it suddenly dawned on me: Hive Mind would be perfect for one of those loud, tropical style shirts that tourists often wear. I then drew my idea out in my sketchbook and scanned it in the computer. I only had to draw one drawing—the image was so strong in my mind that I never had to explore the concept any further. I decided to make the Hive Mind pattern flat, with no shading or dimension, as if the shirt itself was a window that allowed the pattern to show through.

I expanded the pattern and then tweaked the color just a bit, giving it more earthy tones by pumping up the reds and browns so the greens of the surrounding environment would offer a nice contrast. I realized that I could repeat the Hive Mind pattern in the guy's shorts without it looking redundant by making the pattern much smaller and by altering the colors. The two patterns look different enough that they don't clash, yet look like they're from the same collection.

—Ward Jenkins

HAWAIIAN VIBE

Say aloha to mainland clichés and allow some tropical exuberance to
warm up your next project.

⊟ PATTERN COLOR SWATCHES

Hawaiian Vibe_p1

Hawaiian Vibe_p2

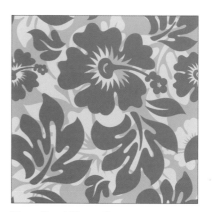

Hawaiian Vibe_p3

⊞ TILED PATTERN

PARLOR

This pattern conjures up a sepia-infused scene: Cognac warmly swirled in the sniffer, a cigar rolled from one side of his mouth to the other. The weathered club chair embraced him as he stared blankly at the ornate, flocked wallpaper. Dust lay like a suffocating blanket on his books and his life.

⊟ PATTERN COLOR SWATCHES

Parlor_p1

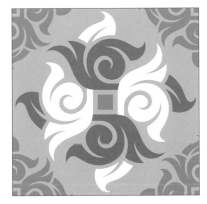
Parlor_p2

Parlor_p3

⊞ TILED PATTERN

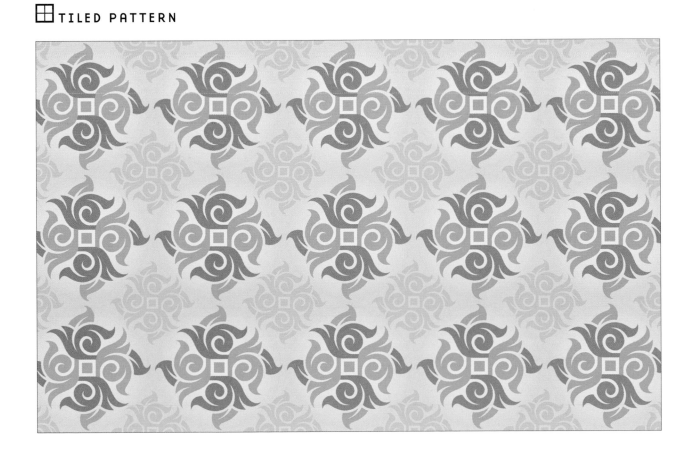

EASTERN LATTICE

Drawn from the ancient, dragon-draped mists of the Forbidden City
(actually from the wall of a local Chinese restaurant), you'll find this
lattice useful as you build your own design dynasty.

▣ PATTERN COLOR SWATCHES

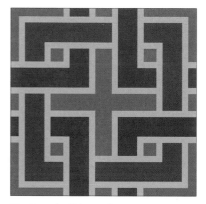

Eastern Lattice_p1 Eastern Lattice_p2 Eastern Lattice_p3

▦ TILED PATTERN

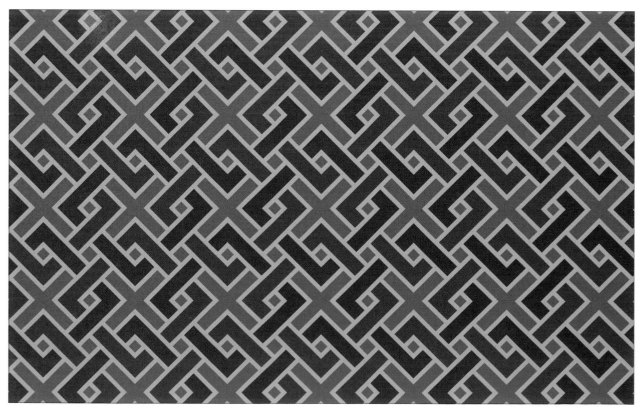

Pattern rotated 45°.

MOTHERBOARD

Computers are cool. Circuits and wires enable me to create artwork and to vacuum floors without lifting a finger. You don't have to be a geek to appreciate the beauty of circuit boards.

⊟ PATTERN COLOR SWATCHES

Motherboard_p1

Motherboard_p2

Motherboard_p3

⊞ TILED PATTERN

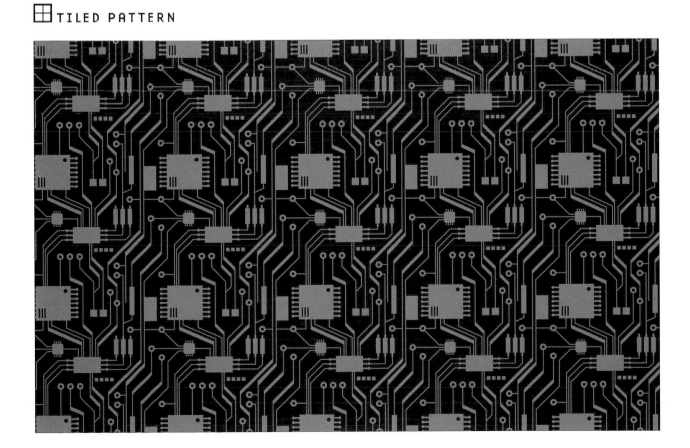

SUMMER PICNIC

In the picnic basket of design options, you'll find this pattern as light and tasty as a cucumber sandwich.

⊟ PATTERN COLOR SWATCHES

Summer Picnic_p1

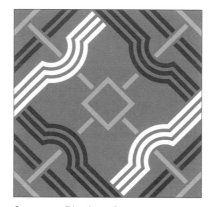
Summer Picnic_p2

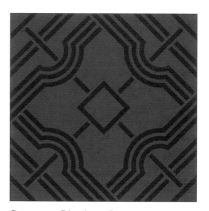
Summer Picnic_p3

⊞ TILED PATTERN

TATTOO PLAID

Harley-riding haggis eaters might be spotted sporting kilts made from this pattern. Also perfect for your next Scottish heavy metal band project.

 PATTERN COLOR SWATCHES

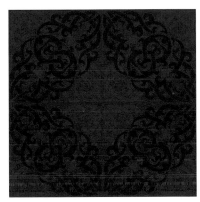 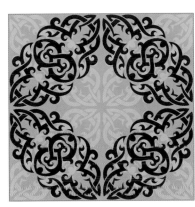 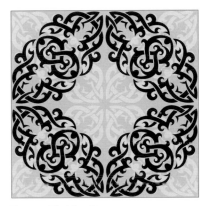

Tattoo Plaid_p1 Tattoo Plaid_p2 Tattoo Plaid_p3

TILED PATTERN

GAELIC MESH

Feeling trapped by the razor wire of habitude? This pattern shouts,
"Freedom!" (from lame design and stale concepts).

⊟ PATTERN COLOR SWATCHES

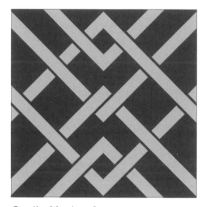

Gaelic Mesh_p1

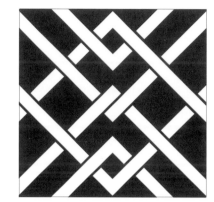

Gaelic Mesh_p2

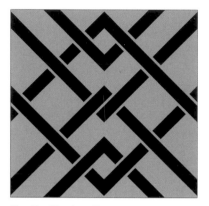

Gaelic Mesh_p3

⊞ TILED PATTERN

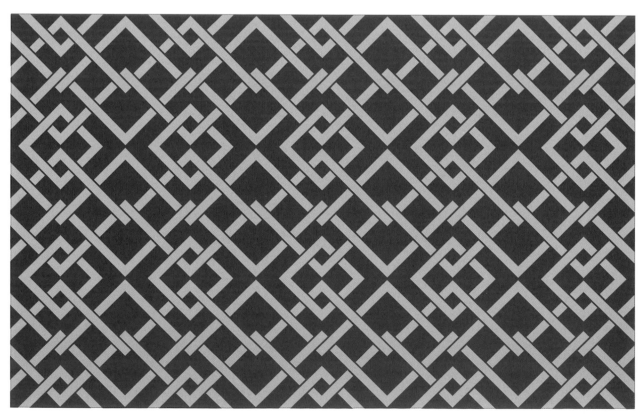

Patricia Zapata

Designer
Texas, USA

www.patriciazapata.com

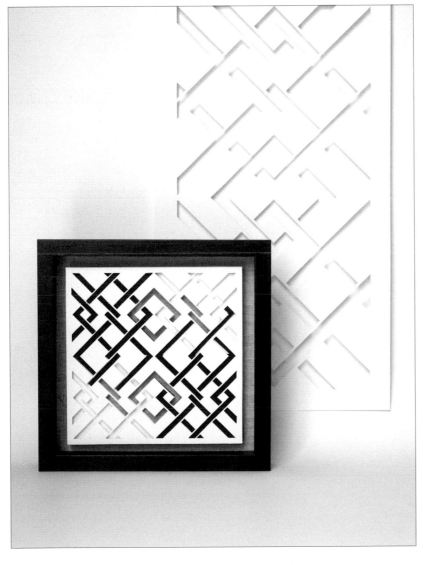

THE MAZE. Artwork created by Patricia Zapata. Copyright © 2008.

DESCRIPTION

Patterns are more commonly used for two-dimensional applications, so I wanted to try something a little different, and a three-dimensional project came to mind. My main objective was to make something that could be used as wall art. I also wanted to show two different styles of the same idea. One is more elaborate, and the other is very simple, but striking in its own way.

The framed piece was created by duplicating the pattern four times so there'd be more detail to work with. The materials used are paper and linen. The role the shadows play is also another important component of this piece. Each of the four layers are cut differently and cast shadows that cause different hues of the three colors to appear.

The background piece was created by enlarging and repeating the pattern twice on a sheet of bristol paper. A thin frame behind the piece makes it appear to float on the wall. It's another and simpler way to show how lights and darks can make an interesting use of the pattern.

—**Patricia Zapata**

INNER CIRCLE

Cliques, secret societies, fraternal groups and other arcane associations—
from neighborhood clubhouses to college sororities to the Illuminati—
everyone's an outsider at one time in his life. Who needs them? Create
your own elite mythology with this esoteric design.

⊟ PATTERN COLOR SWATCHES

Inner Circle_p1

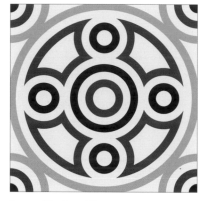

Inner Circle_p2

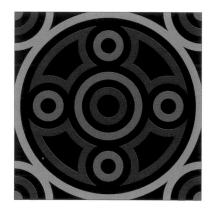

Inner Circle_p3

⊞ TILED PATTERN

TRUE VINE

Graft this undulating ivy into your next project.

▭ PATTERN COLOR SWATCHES

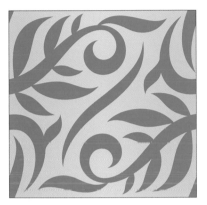

True Vine_p1

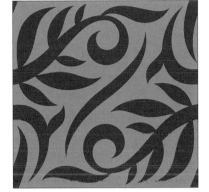

True Vine_p2

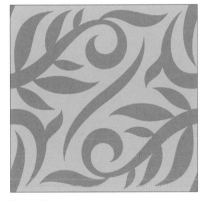

True Vine_p3

⊞ TILED PATTERN

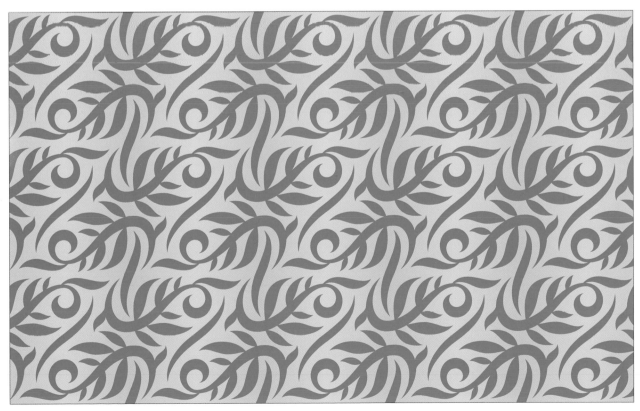

TURTLE STACK

Interlocking turtlelike shapes will enhance your pet project. Slow but steady design ensures you win the race.

▣ PATTERN COLOR SWATCHES

Turtle Stack_p1

Turtle Stack_p2

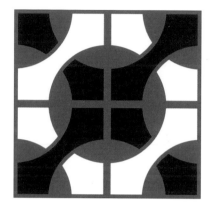

Turtle Stack_p3

⊞ TILED PATTERN

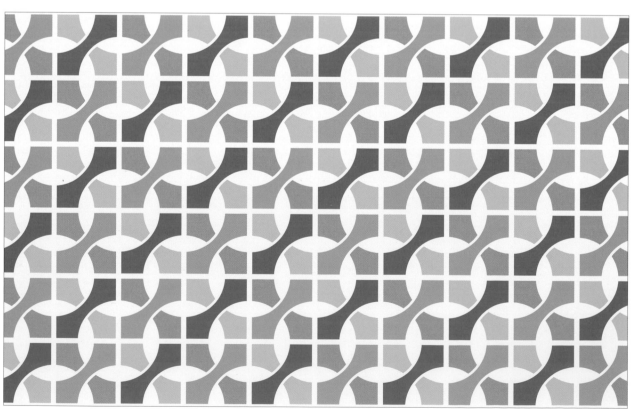

SPA FLOOR

Serene and restrained, this upscale tiled pattern will inspire you to put on
a cucumber masque and get a pedicure. Slip in a Yanni CD, and you'll be
ready to massage any concept into its final form.

⊟ PATTERN COLOR SWATCHES

Spa Floor_p1

Spa Floor_p2

Spa Floor_p3

⊞ TILED PATTERN

TRIBAL FLAIR

My skin is ink-free. I admit, I'm a weenie and can't stand the pain of the needle. But more importantly, I'd quickly tire of the dermal decorations. Still, drawing tribal tattoo art is one of my favorite themes. I hope this Māori-inspired pattern etches permanent marks in your design aesthetic.

⊟ PATTERN COLOR SWATCHES

Tribal Flair_p1

Tribal Flair_p2

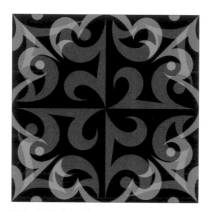

Tribal Flair_p3

⊞ TILED PATTERN

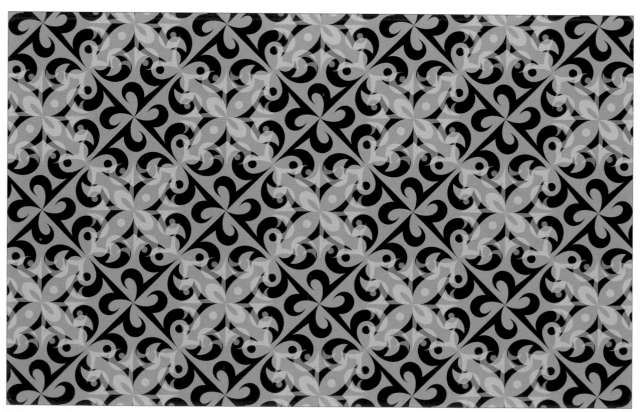

Pattern rotated 45°.

NODE MATRIX

A graphic prognostication of what futuristic chain link may look like...
a high-tech fence that prevents your robot dog from wandering away and
keeps out those pesky mutant clones.

⊟ PATTERN COLOR SWATCHES

Node Matrix_p1 Node Matrix_p2 Node Matrix_p3

⊞ TILED PATTERN

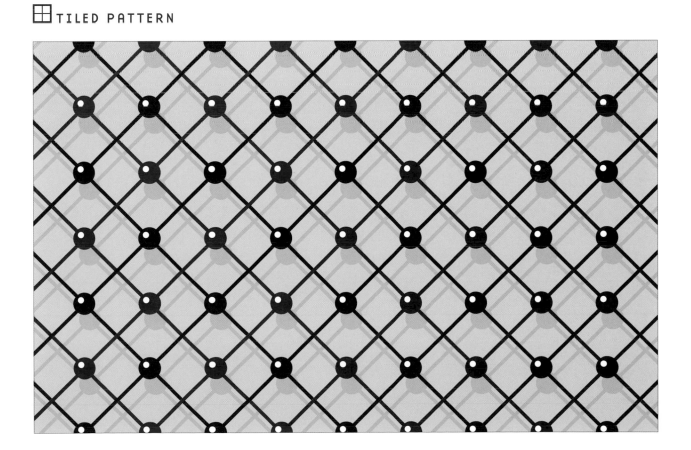

ALIEN CELLS

My neighbor, retired from the Air Force, previously lived in New Mexico. He possesses photos ascribed to the infamous Roswell UFO crash. This design mimics a microscope photo of alien flesh he showed me. Shiver. Watch out for rapidly moving, flashing lights in the evening sky.

⊟ PATTERN COLOR SWATCHES

Alien Cells_p1

Alien Cells_p2

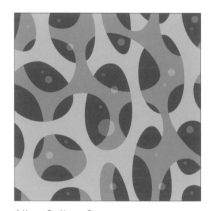

Alien Cells_p3

⊞ TILED PATTERN

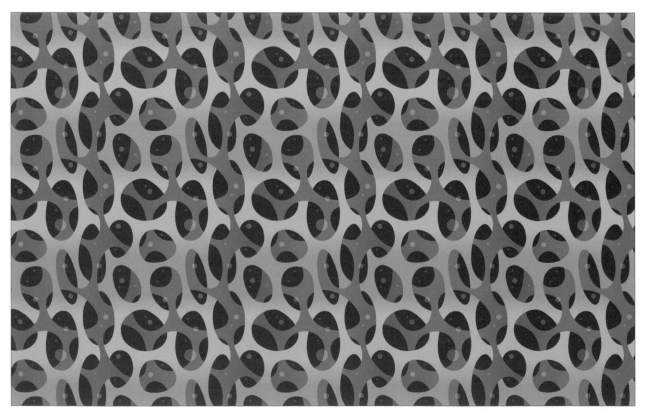

GARDEN STONE

From digital projects to do-it-yourself patios, the path of design glory is
paved by the lush world of patterns.

⊟ PATTERN COLOR SWATCHES

Garden Stone_p1

Garden Stone_p2

Garden Stone_p3

⊞ TILED PATTERN

Pattern rotated 45°.

ZIMBABWE

From impassable jungles—heat-soaked and echoing with exotic bird cries—comes this authentic pattern gleaned from a remote tribe's traditional warrior garments. Actually, I just doodled it during a recent meeting.

 PATTERN COLOR SWATCHES

Zimbabwe_p1

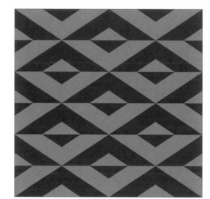

Zimbabwe_p2

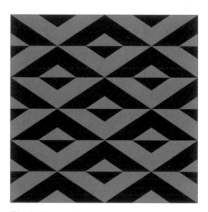

Zimbabwe_p3

⊞ TILED PATTERN

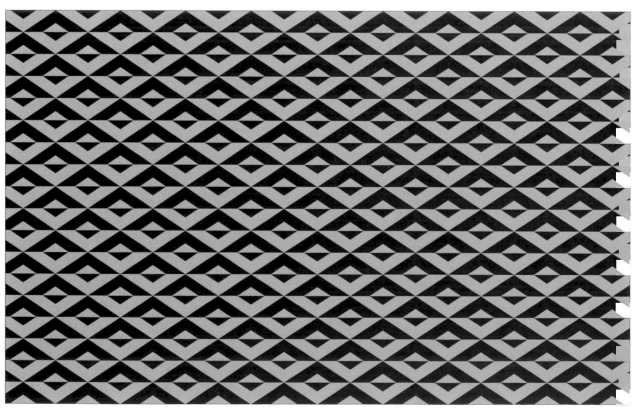

Joe Montgomery

Designer
Wednesday Design
Tennessee, USA

www.wednesday-design.com

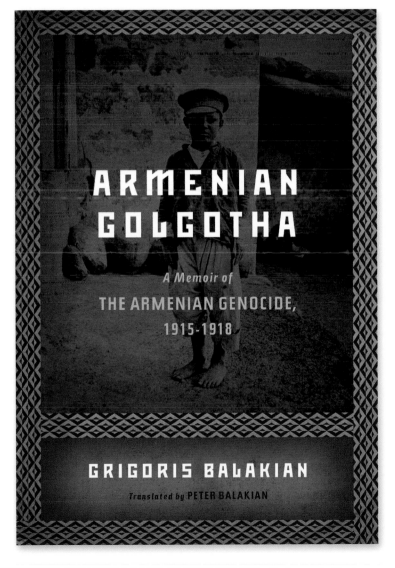

ARMENIAN GOLGOTHA BOOK JACKET DESIGN. Design created by Joe Montgomery. Copyright © 2008.

DESCRIPTION

The pattern I chose is Zimbabwe. It's a nice, bold and simple pattern that I thought could be used in a wide variety of ways and would work for many different styles. I imagine it would work on any project requiring a non-specific, tasteful border or ornamentation. I like the bold geometry and implied visual depth of the pattern.

I wanted to use the pattern in a "real-world" application, so the project I chose to do was a jacket concept for the book *Armenian Golgotha* by Grigoris Balakian, to be published by Alfred A. Knopf.

I thought the pattern would be relevant and applicable to the project—specifically through altering the colors and textures. I changed the colors to mimic those of the Armenian flag, and I applied an old, weathered paper overlay onto the pattern to give it more visual interest and subtlety. I like how the pattern's bright, almost festive look contrasts with the sad image of the Armenian orphan boy, which is fitting since the book touches on hope and optimism in the midst of a dark and horrible chapter in history.

—Joe Montgomery

VIA DOLOROSA

In Israel, I traversed an Old Jerusalem street lined with ornate Byzantine buildings. On one edifice was an exquisite floral carving that inspired this design.

▣ PATTERN COLOR SWATCHES

Via Dolorosa_p1

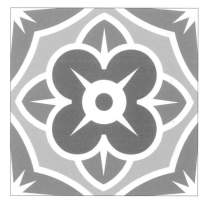

Via Dolorosa_p2

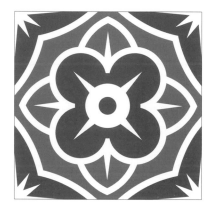

Via Dolorosa_p3

▦ TILED PATTERN

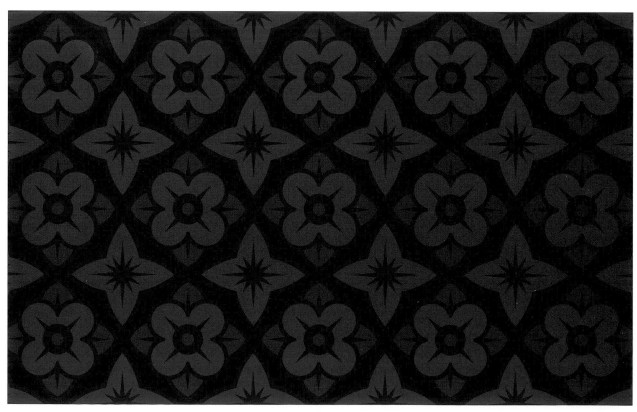

SPRING GROWTH

Here in my lifelong home, the Pacific Northwest, we have no shortage of greenery...and rain. Enjoy this verdant labyrinth designed to shower your project with a touch of vegetative splendor.

⊟ PATTERN COLOR SWATCHES

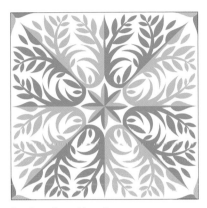

Spring Growth_p1

Spring Growth_p2

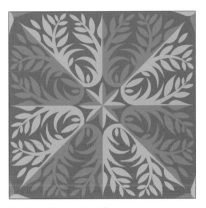

Spring Growth_p3

⊞ TILED PATTERN

Pattern rotated 45°.

REGAL

Intricate and illustrious interlocking items interest and incite imaginative illustrators.

⊟ PATTERN COLOR SWATCHES

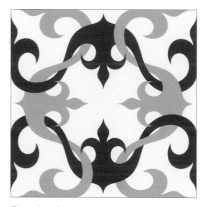

Regal_p1

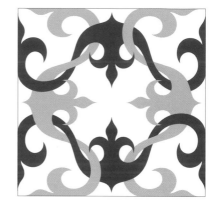

Regal_p2

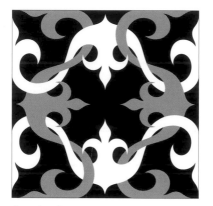

Regal_p3

⊞ TILED PATTERN

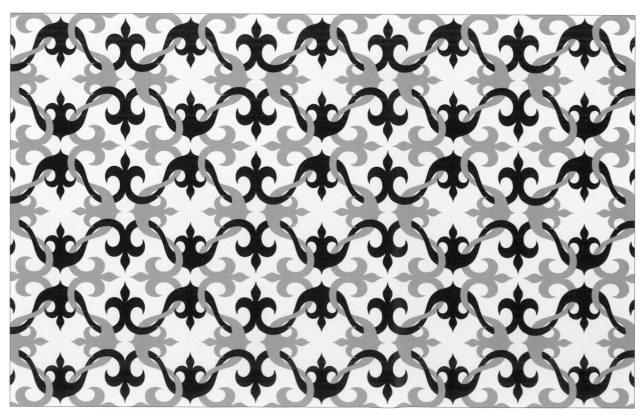

COHESION

This is a close-up of an imaginary creature, the desert gecko, pigmented
like a maze of fiery, connected molecules.

⊟ PATTERN COLOR SWATCHES

Cohesion_p1

Cohesion_p2

Cohesion_p3

⊞ TILED PATTERN

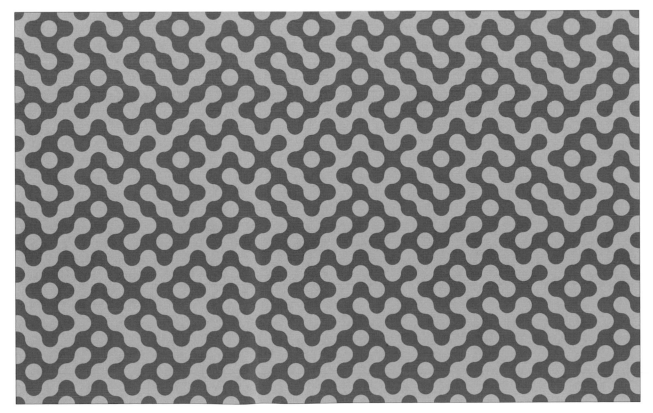

FLAME BROILED

My original title was going to be "Hell Yes!" but my wife thought it might offend someone. So, I thought, hmm, "Kittens and Unicorns at a Summer Campfire Listening to Céline Dion" might be less likely to offend sensitive souls. My editors suggested "Flame Broiled" as a good compromise.

⊟ PATTERN COLOR SWATCHES

 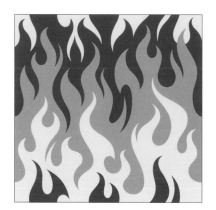

Flame Broiled_p1 Flame Broiled_p2 Flame Broiled_p3

⊞ TILED PATTERN

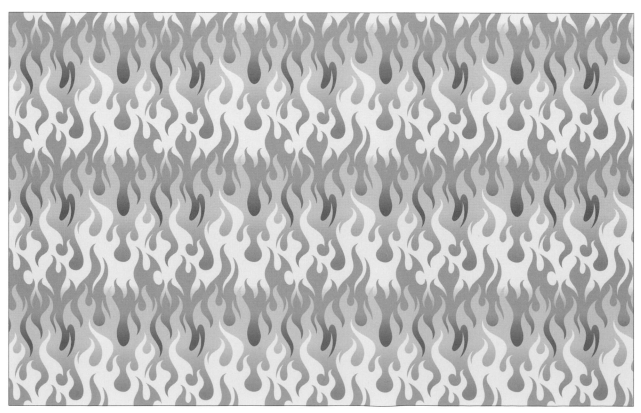

DRAGON HIDE

This scalable pattern breathes fire into your project, whether you're illustrating a dragon or just your mother-in-law.

⊟ PATTERN COLOR SWATCHES

Dragon Hide_p1

Dragon Hide_p2

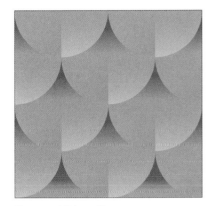

Dragon Hide_p3

⊞ TILED PATTERN

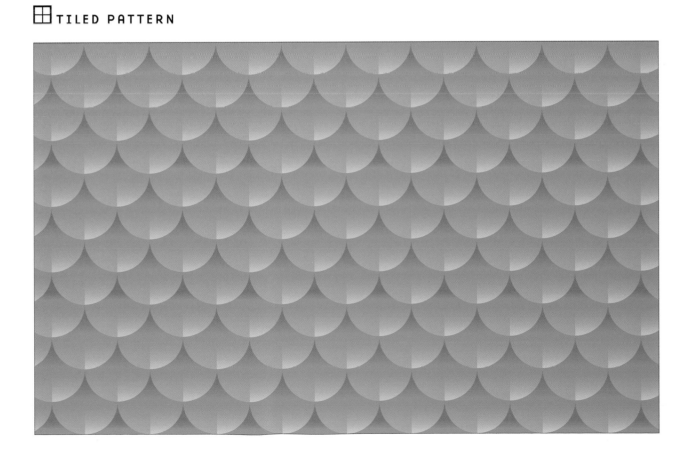

CHECKMATE

You don't have to be a nerd or brilliant strategist to recognize this chess-inspired pattern is a good move.

⊟ PATTERN COLOR SWATCHES

Checkmate_p1

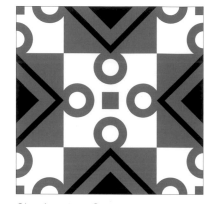

Checkmate_p2

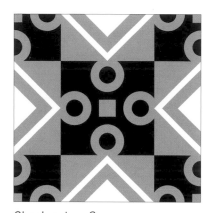

Checkmate_p3

⊞ TILED PATTERN

KALEIDOSCOPE

One of my early exposures to artistic patterns was when I was a little kid, staring into a kaleidoscope. Shifting, symmetrical arrangements suggested an infinity of multicolored dream worlds.

▣ PATTERN COLOR SWATCHES

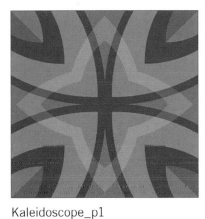

Kaleidoscope_p1

Kaleidoscope_p2

Kaleidoscope_p3

▦ TILED PATTERN

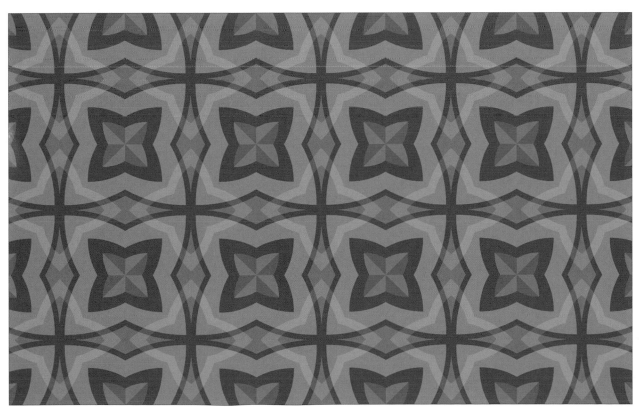

MOD DROP

This is wallpaper suitable for a beatnik coffee shop, inspired by the jet age, jetsetters and the Jetsons. Hip pods for the hepcat mods. Designed by Paul Howalt.

 PATTERN COLOR SWATCHES

 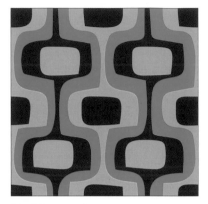 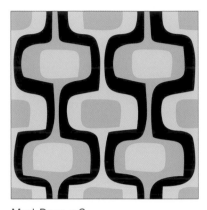

Mod Drop_p1 Mod Drop_p2 Mod Drop_p3

⊞ TILED PATTERN

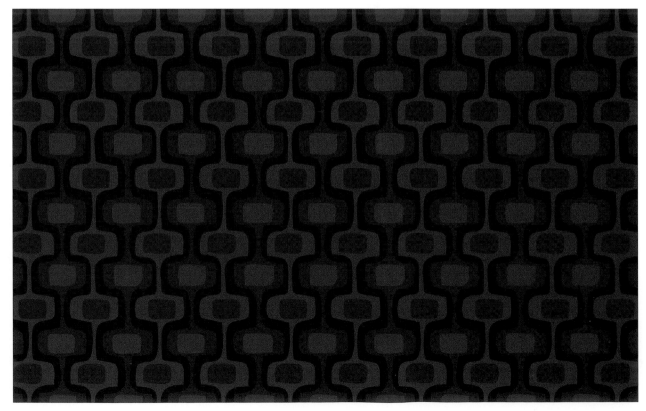

Paul Howalt

Illustrator & Designer
Arizona, USA

www.tactixcreative.com
www.paulhowalt.com

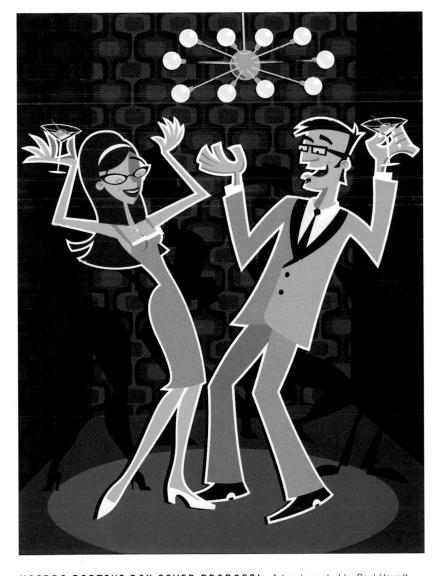

HASBRO PARTINI BOX COVER PROPOSAL. Artwork created by Paul Howalt.
Copyright © 2008.

DESCRIPTION

This piece started out as the box top illustration for Hasbro's new adult party game called *Partini*. I was initially hired to design the game pieces, coaster cards and instruction manual, but was left out of the box design development (which was completed before my portion of the project began). I noticed that the cover was assembled from bits and pieces from a popular stock illustration site, so I thought I'd propose a more custom solution to them. I used one of the more retro-looking pattern tiles I created for this book. It was appropriate for the look and feel of the game as well as the cards that I had designed. I thought that the pattern worked well as a contrasting wallpaper behind the dancing figures.

By the time I had finished, I was too late, they had already shipped off the box art to be printed. Now it lives on in this book instead.

—**Paul Howalt**

59

HEXAFLAKE
High tech meets low temps with cool results. It's art in the Arctic zone.

 PATTERN COLOR SWATCHES

 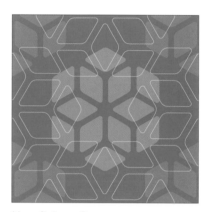

Hexaflake_p1 Hexaflake_p2 Hexaflake_p3

⊞ TILED PATTERN

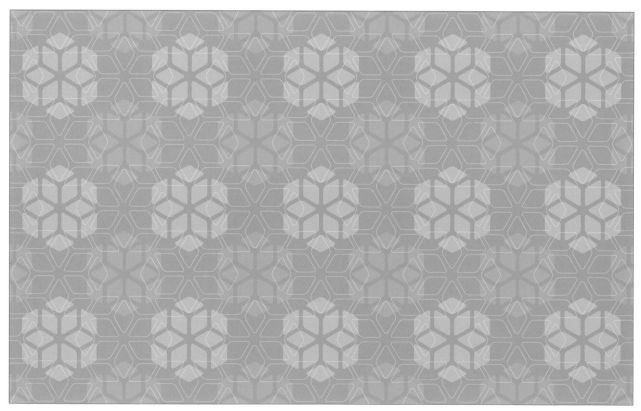

OFFSET CAMO

Technicolor pixelated rainbow blobs form a hazy moiré. The remains of a paintball battle? A comic book under magnification? Or digital tie-dye? Maybe you just need to clean your glasses and sit farther back from the monitor.

 PATTERN COLOR SWATCHES

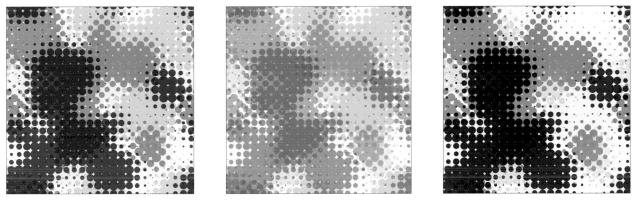

Offset Camo_p1 Offset Camo_p2 Offset Camo_p3

 TILED PATTERN

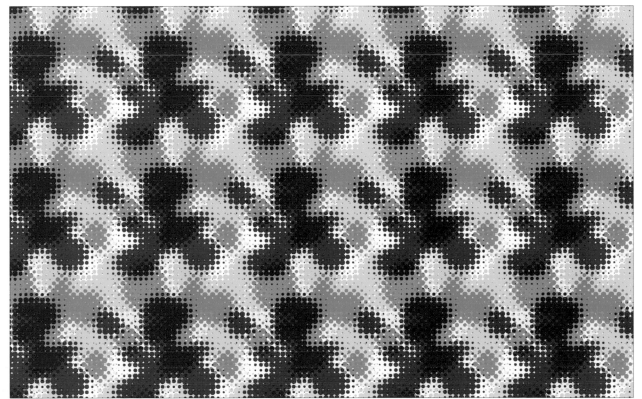

CAT'S EYE

Originally inspired by my cat, Snickers, this mod feline lozenge is apt for
bowling alley décor, a polyester pantsuit or airline seat fabric.

⊟ PATTERN COLOR SWATCHES

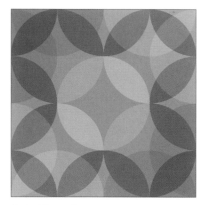

Cats Eye_p1

Cats Eye_p2

Cats Eye_p3

⊞ TILED PATTERN

LOOM
Weave this pattern into your next design and clothe yourself with
graphic success.

▣ PATTERN COLOR SWATCHES

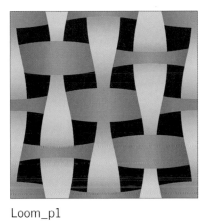

Loom_p1

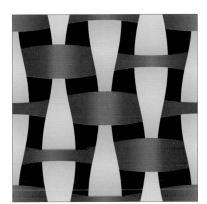

Loom_p2

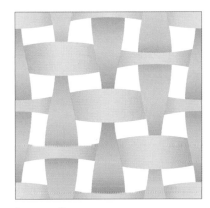

Loom_p3

▦ TILED PATTERN

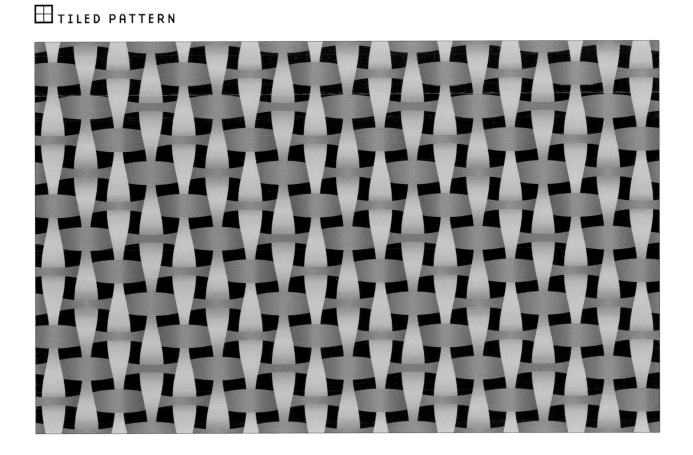

ROSETTA

May the fire of a thousand suns singe your keyboard if you fail to be inspired by this solar rose.

⊟ PATTERN COLOR SWATCHES

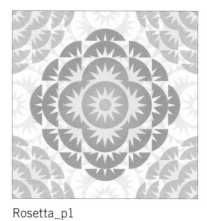

Rosetta_p1

Rosetta_p2

Rosetta_p3

⊞ TILED PATTERN

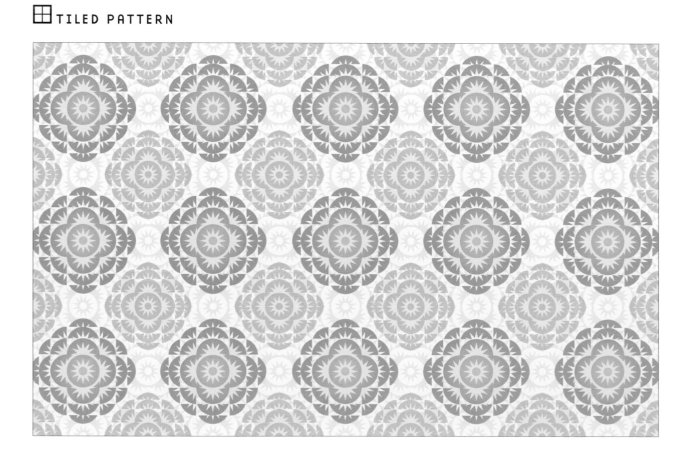

HYPNOTICA

Stare deeply enough at this *Twilight Zone* of patterns, and you'll get sleepy... very sleepy. Then you'll start clucking like a chicken.

⊟ PATTERN COLOR SWATCHES

Hypnotica_p1 Hypnotica_p2 Hypnotica_p3

⊞ TILED PATTERN

FRILLICIOUS

As if drawn by an elf, lacy filigrees uncurl across the page in delicate magical swirls.

 PATTERN COLOR SWATCHES

Frillicious_p1 Frillicious_p2 Frillicious_p3

⊞ TILED PATTERN

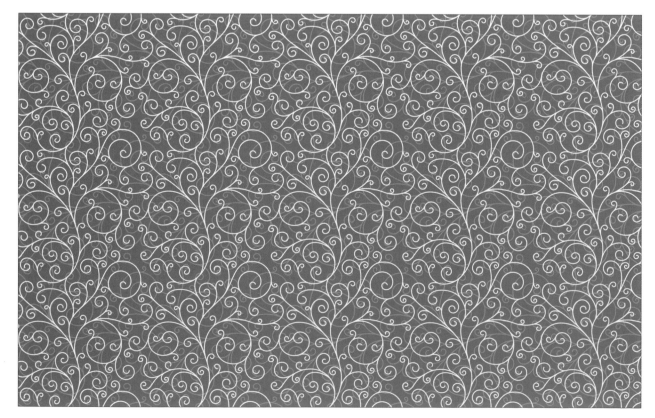

VECTOR BOUQUET
Blooming Béziers! This artistic flower bed will make any layout blossom.

⊟ PATTERN COLOR SWATCHES

Vector Bouquet_p1

Vector Bouquet_p2

Vector Bouquet_p3

⊞ TILED PATTERN

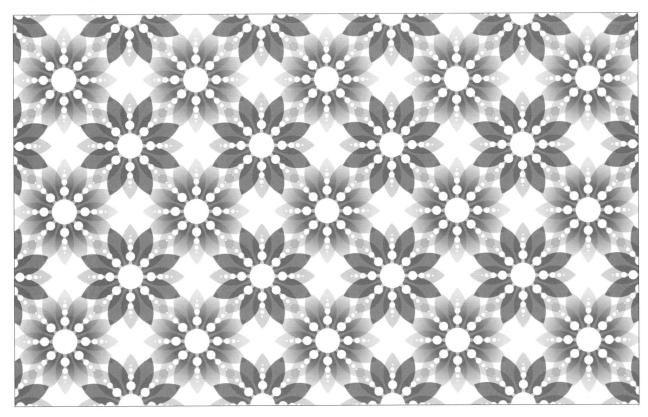

BASKET CASE

Something wicker this way comes...a flat lattice pattern that will help you weave stunning designs.

▣ PATTERN COLOR SWATCHES

Basket Case_p1

Basket Case_p2

Basket Case_p3

▦ TILED PATTERN

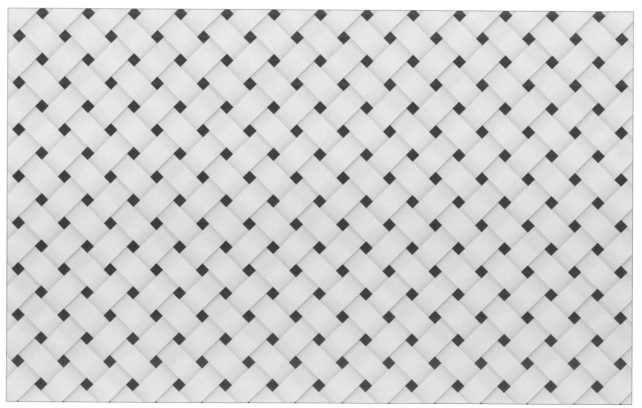

Pattern rotated 45°

Greg Epkes

Illustrator
Oregon, USA

www.epkes.com

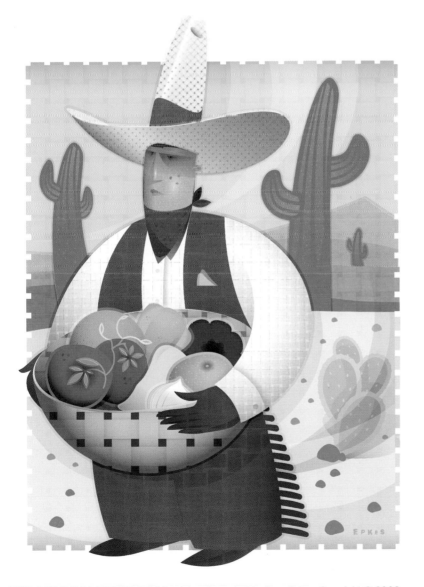

THE DUDE BRINGETH FOOD. Artwork created by Greg Epkes. Copyright © 2008.

DESCRIPTION

Giddy up buckaroo farmer! This fruit-bearing desperado is corralling a basket full of bounty through the desert high plains.

I've always liked the imagery of the desert and how the cactus mimics the shape of a cowboy's hat.

—**Greg Epkes**

LAUREL

Before its humble gig as soup seasoning, bay laurel crowned gods, con-
querors and Olympians. To the victors go the spoils…and they get the
best patterns, too.

 PATTERN COLOR SWATCHES

 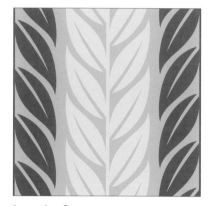 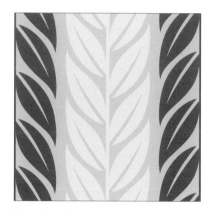

Laurel_p1 Laurel_p2 Laurel_p3

 TILED PATTERN

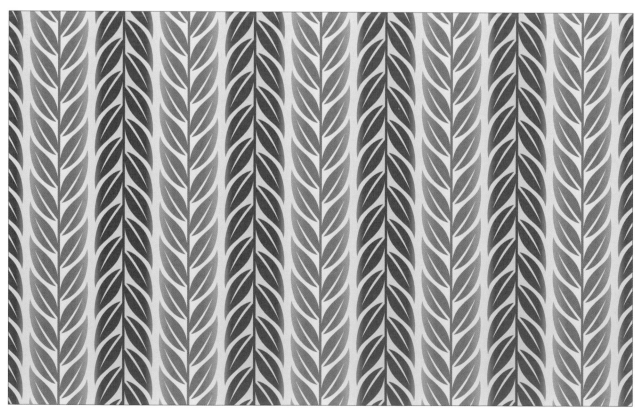

OCTANET

Methodical molecules link arms. This was inspired from close-up shots of bio-engineered body armor being developed by DARPA (The Defense Advanced Research Projects Agency).

⊟ PATTERN COLOR SWATCHES

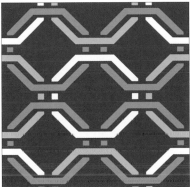 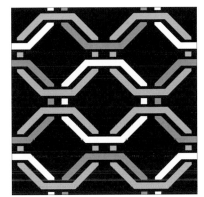 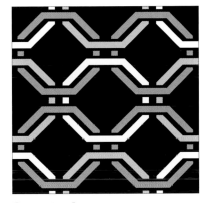

Octanet_p1 Octanet_p2 Octanet_p3

⊞ TILED PATTERN

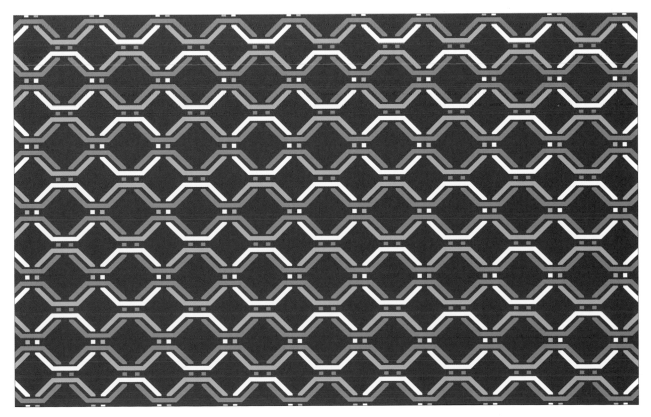

RETROGRADE

Contortionist fibers resemble flexible boomerangs knotted into scribbled mesh. A classic motif, reminiscent of the atomic age.

▤ PATTERN COLOR SWATCHES

Retrograde_p1

Retrograde_p2

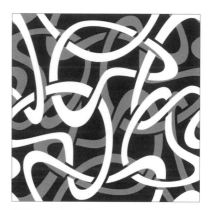

Retrograde_p3

⊞ TILED PATTERN

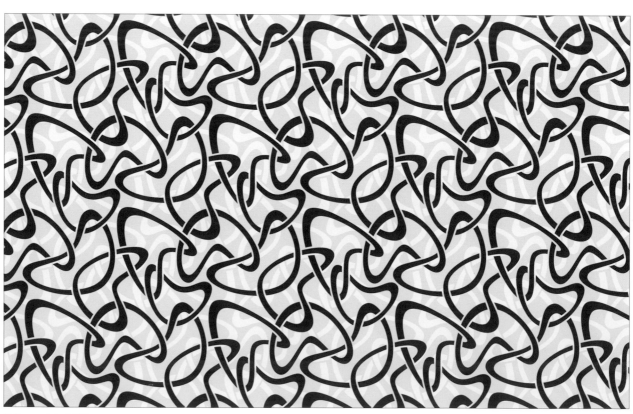

Pattern rotated 45°.

RIPPLE EFFECT

Drop a rock in a pond and watch ripples spread in expanding concentric circles. It's my hope that this design will make waves in your project as well.

⊟ PATTERN COLOR SWATCHES

Ripple Effect_p1 Ripple Effect_p2 Ripple Effect_p3

⊞ TILED PATTERN

INTERLINK

Luxe rings clasped into gilt chains were forged from a rejected logo concept. I like to repurpose art. With a little creativity, inferior ideas can become golden in the end.

⊟ PATTERN COLOR SWATCHES

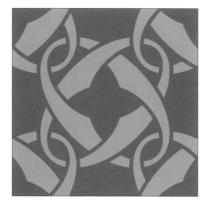 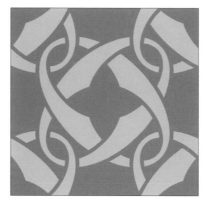 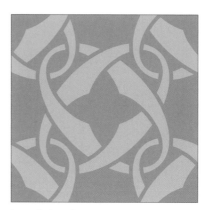

Interlink_p1 Interlink_p2 Interlink_p3

⊞ TILED PATTERN

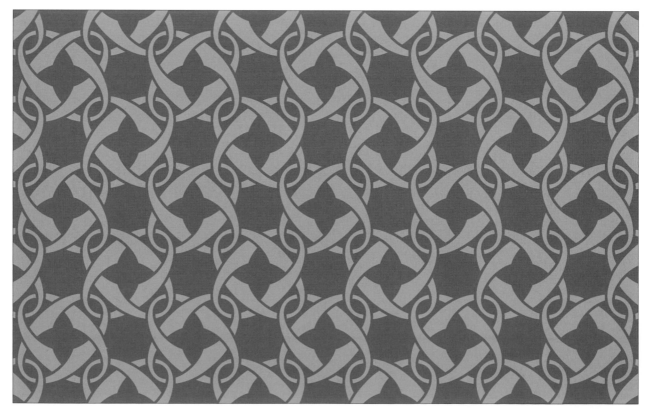

ALCOVE

Square, hivelike recesses provide a niche for creative ideas.

⊟ PATTERN COLOR SWATCHES

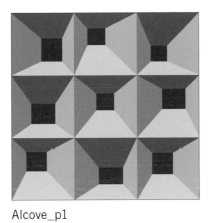

Alcove_p1

Alcove_p2

Alcove_p3

⊞ TILED PATTERN

NEO ARGYLE

My dad had a thing for argyle socks. He was also color blind, which re-
sulted in some interesting sets. Perhaps my heightened sense of color is
due to paternal hosiery decisions? (I love you, Dad!)

⊟ PATTERN COLOR SWATCHES

Neo Argyle_p1

Neo Argyle_p2

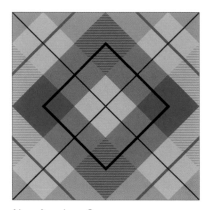

Neo Argyle_p3

⊞ TILED PATTERN

Rian Hughes

Illustrator & Designer
London, UK

www.rianhughes.com
www.devicefonts.co.uk

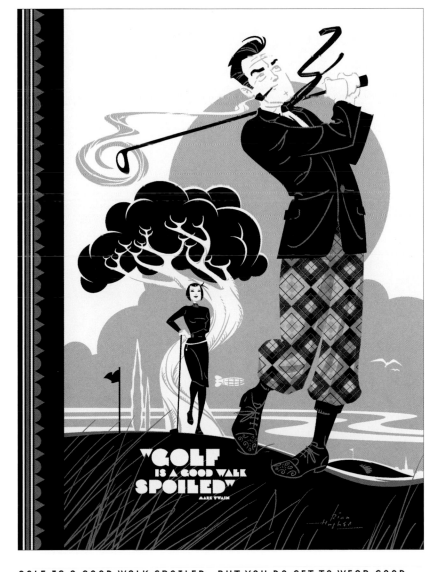

GOLF IS A GOOD WALK SPOILED—BUT YOU DO GET TO WEAR GOOD
TROUSERS. Artwork created by Rian Hughes. Copyright © 2008.

DESCRIPTION

I chose the Neo Argyle pattern chiefly because it's not the kind of pattern I'd usually be associated with or use. It's often interesting to push against type and set yourself a challenge. The pattern suggested the kind of clothing a traditional golfer might wear, so here he is, in full British golfing gear, teeing off in style. The illustration is done in Adobe Illustrator using blocks of vector shapes laid over with linework using the "brush" tool. To begin with, the jacket was also patterned, but this tended to overpower the shape of the golfer's body and make the image harder to read, so in the final version just the trousers shout out. I kept the rest of the illustration black and white to emphasize the patterned area. He'll be sipping Pimms in the clubhouse with his ladyfriend in a few minutes. Personally, I'm with Mark Twain on the joys of golf, hence the quote.

—**Rian Hughes**

CRYSTALYN

A gemlike petal mosaic will activate your artistic alchemy.

▣ PATTERN COLOR SWATCHES

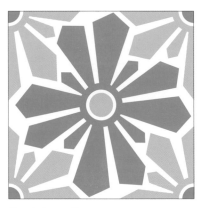

Crystalyn_p1

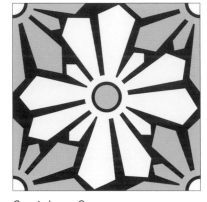

Crystalyn_p2

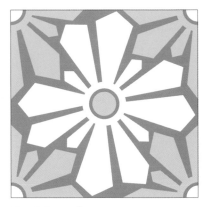

Crystalyn_p3

⊞ TILED PATTERN

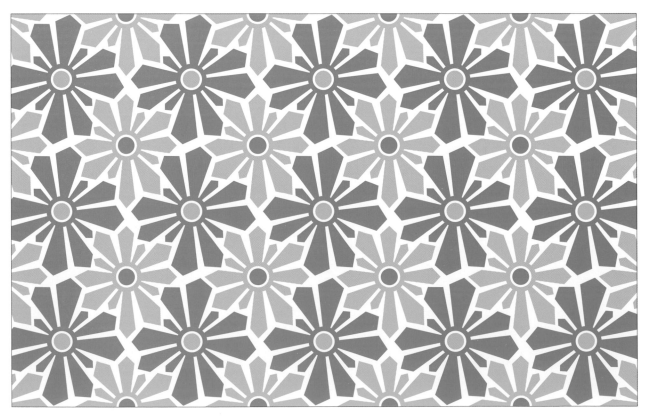

BIOCULTURAL

Biologically-speaking, we all come from the same culture. Despite our different geographical locations, variations in skin color and wide array of beliefs, in the end we are all part of the same pattern of humanity. This simple truth inspired this pattern.

⊟ PATTERN COLOR SWATCHES

Biocultural_p1 Biocultural_p2 Biocultural_p3

⊞ TILED PATTERN

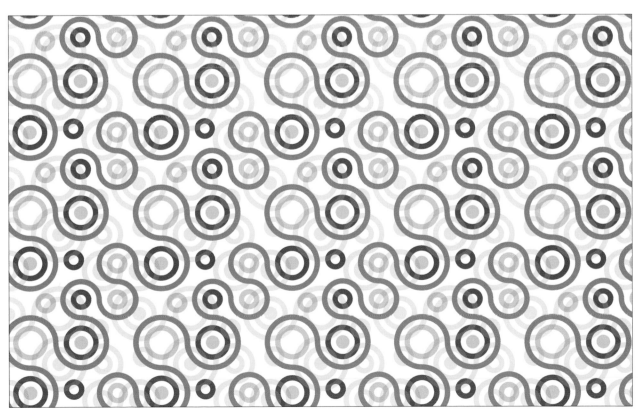

CELTIC WEAVE

If you don't like this design, it's *knot* my fault! Creative lads and lassies
will fabricate fair treatments from this intricate weave.

⊟ PATTERN COLOR SWATCHES

Celtic Weave_p1

Celtic Weave_p2

Celtic Weave_p3

⊞ TILED PATTERN

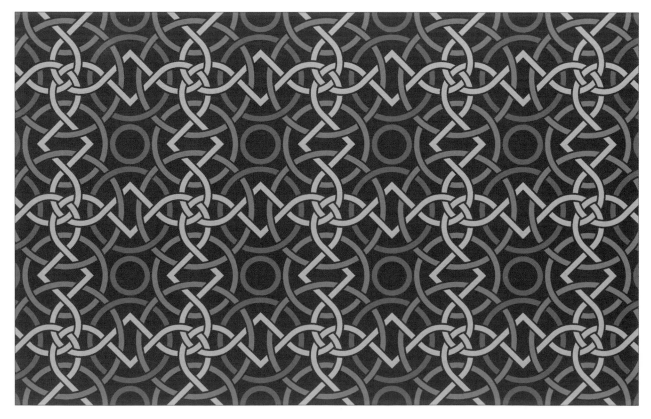

COMET-OSE

Be awakened from design slumber with an explosion of astronomical objects. Illustrative fireworks ensue when you reach for the stars.

⊟ PATTERN COLOR SWATCHES

Comet-ose_p1 Comet-ose_p2 Comet-ose_p3

⊞ TILED PATTERN

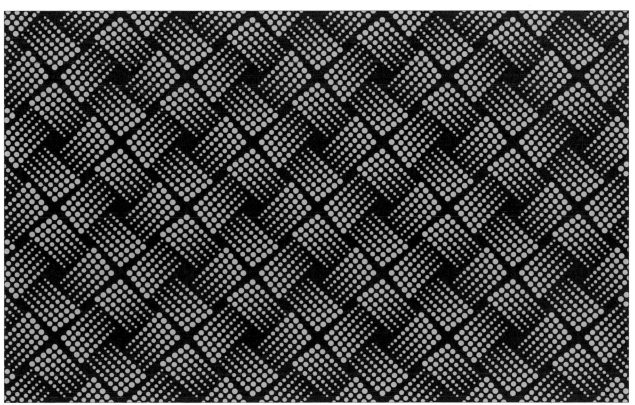

MAGIC BEANS

Fee, fie, foe, fum…here's a pattern that adds a whole new dimension to
the term "stalk art." Use this legumelike illustration to add organic flair
and to kill the giant of ho-hum design.

⊟ PATTERN COLOR SWATCHES

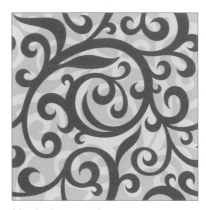
Magic Beans_p1

Magic Beans_p2

Magic Beans_p3

⊞ TILED PATTERN

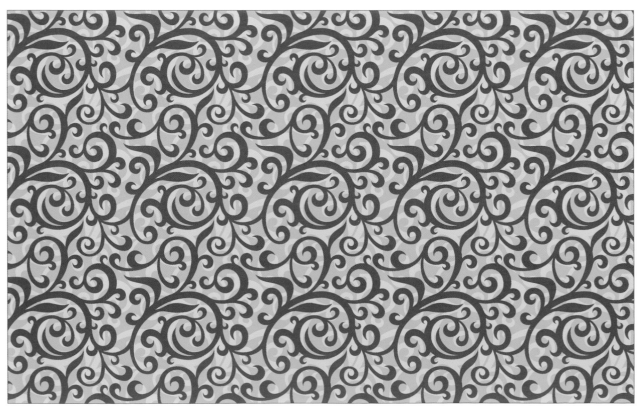

CONTORNO

Olé! Festive and lively, just like a Spanish wedding. Kiss the bride and dance with the grandmother, or vice versa.

⊟ PATTERN COLOR SWATCHES

 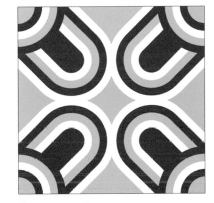

Contorno_p1

Contorno_p2

Contorno_p3

⊞ TILED PATTERN

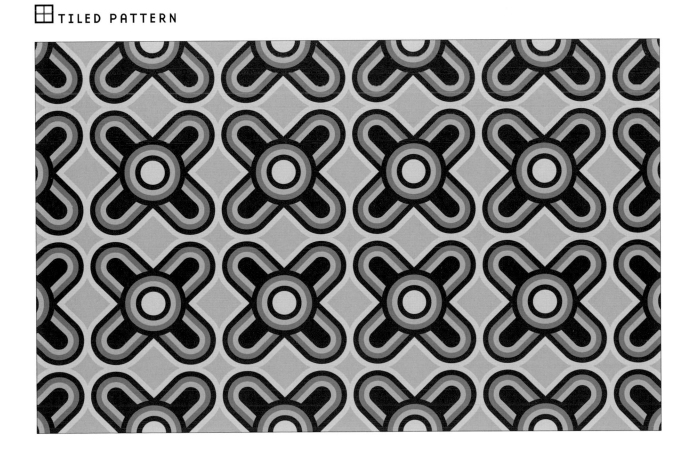

EQUUS BURCHELLI

Nineteenth-century naturalist William John Burchell returned to England
with over fifty thousand specimens, including examples of this rare plains
zebra that now bears his name.

⊟ PATTERN COLOR SWATCHES

Equus Burchelli_p1

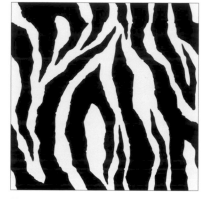
Equus Burchelli_p2

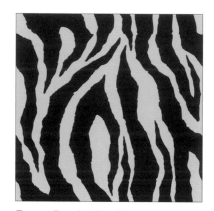
Equus Burchelli_p3

⊞ TILED PATTERN

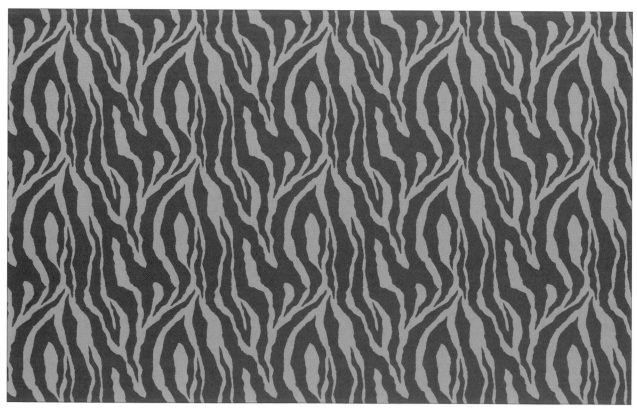

PROTOZOA

Like a pebbled terrazzo, single-cell organisms spread out across the page.
The nucleus of your project can be this pattern.

 PATTERN COLOR SWATCHES

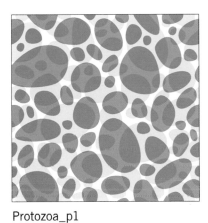

Protozoa_p1

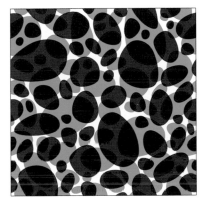

Protozoa_p2

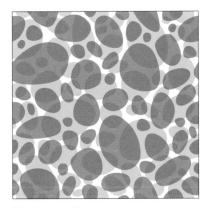

Protozoa_p3

⊞ TILED PATTERN

THORN BLOSSOM

With endurance of hardship, pain and struggle blooms hope and beauty.
Every rose has its thorns.

▤ PATTERN COLOR SWATCHES

Thorn Blossom_p1

Thorn Blossom_p2

Thorn Blossom_p3

⊞ TILED PATTERN

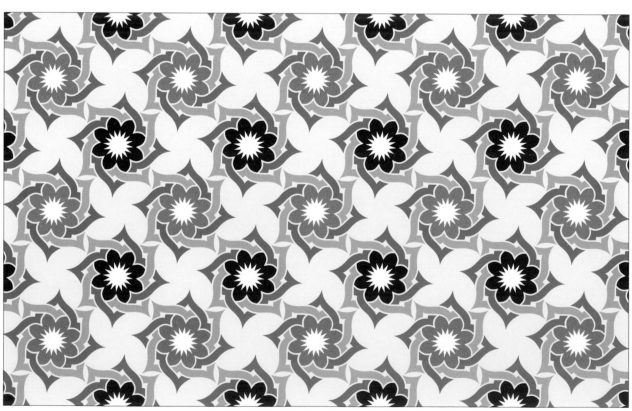

FEATURED ARTIST

Sherwin Schwartzrock

Designer & Illustrator
Minnesota, USA

www.schwartzrock.com

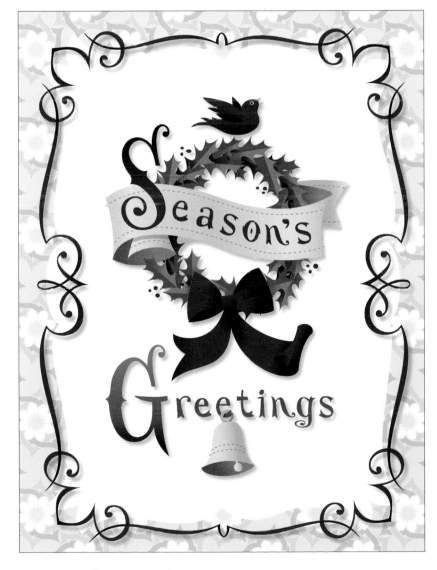

DESCRIPTION

Jeanmarie Creations asked me to create a fresh design for their Christmas collection. With that in mind, I decided a classical design would be appropriate, but with a more modern and fun interpretation. I began by researching antique Christmas cards. I wanted to capture an essence of those cards produced around 1900. All my elements were assembled in a classical layout surrounded by an ornamental frame design. Once I had a composition sketched the way I wanted, I then started rendering all of these elements, including the type, in a whimsical and playful style.

The border or framing treatment was critical. Amazingly, I had selected Thorn Blossom weeks earlier, not knowing what project I would use it for. Little did I know it would be ideal for this project. It gave the illustration just the right amount of detail, style and history. If you look at the image without the pattern, the illustration looks weak and bland. The cards of that era used a lot of refined detail. Since my illustration style is void of a lot of detail, I needed the pattern to do the job for me.

—Sherwin Schwartzrock

SEASON'S GREETINGS. Artwork created by Sherwin Schwartzrock.
Copyright © 2008.

EFFERVESCENCE

Sink into this frothy, fizzy world of carbonation and watch inspiration sparkle like champagne around you.

⊟ PATTERN COLOR SWATCHES

Effervescence_p1

Effervescence_p2

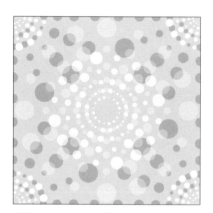

Effervescence_p3

⊞ TILED PATTERN

BUGABOO

Bring back those parachute pants and lighted dance floors... it's time to get your groove on! Let's put the funk back into design functionality.

◱ PATTERN COLOR SWATCHES

Bugaboo_p1 Bugaboo_p2 Bugaboo_p3

⊞ TILED PATTERN

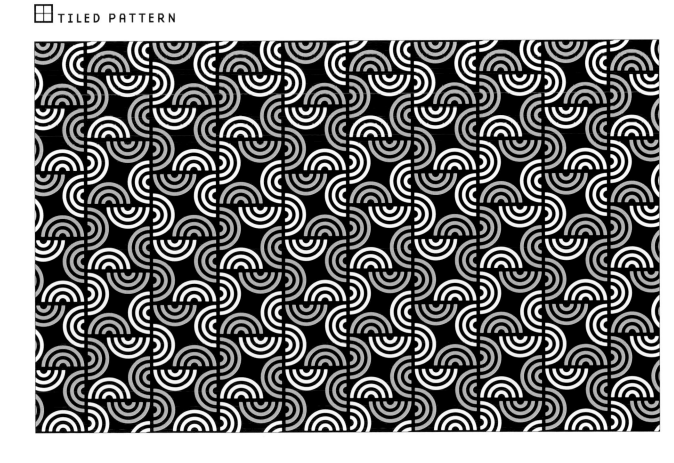

VECTOGRAPHICAL

Care to combine the topographical and typographical? Then put on your hiking boots and explore the terrain of good design.

⊟ PATTERN COLOR SWATCHES

Vectographical_p1

Vectographical_p2

Vectographical_p3

⊞ TILED PATTERN

EL SHADDAI

While on a recent trip to Jerusalem, I caught glimpses of ornate, beautiful design in the most unexpected places. This pattern speaks of the purity of fire, the intricacy of life and the weight of the invisible in this world.

 PATTERN COLOR SWATCHES

El Shaddai_p1

El Shaddai_p2

El Shaddai_p3

⊞ TILED PATTERN

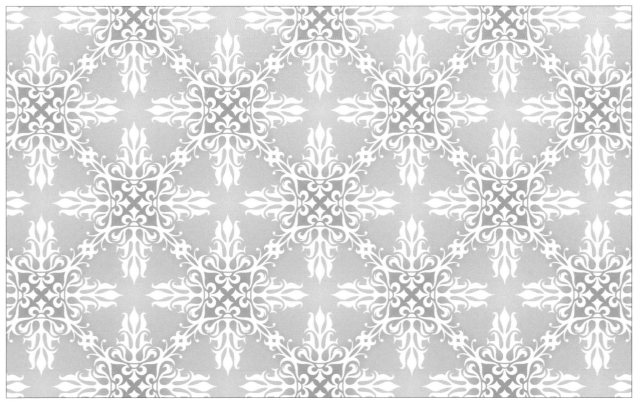

Pattern rotated 45°.

BOOGIE POP

Back in elementary school, I got hit in the head with a baseball bat. That was the first time I saw this pattern. You get to enjoy this woozy marvel minus the pain and intermittent disorientation.

⊟ PATTERN COLOR SWATCHES

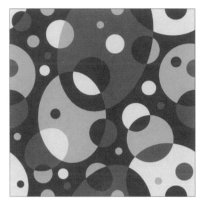
Boogie Pop_p1

Boogie Pop_p2

Boogie Pop_p3

⊞ TILED PATTERN

GREENER

This pattern is for you: the nature-loving, tree-hugging, tofu-eating, bongo-drumming, razor-avoiding, water-conserving, biofuel-using, hemp-crafting, tie-dye-sporting tribe—known in the Northwest as the Greeners.

⊟ PATTERN COLOR SWATCHES

Greener_p1

Greener_p2

Greener_p3

⊞ TILED PATTERN

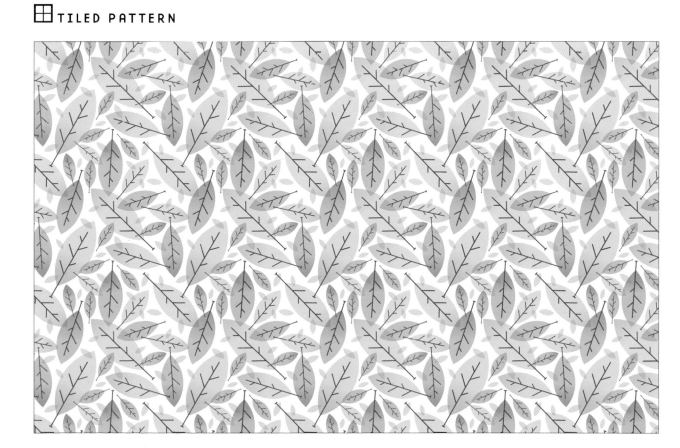

PSYCHOTRONIC

This hypnotic, pulsating hyperdrive is from the control panel of an extraterrestrial cruiser. My neighbor believes he was abducted by aliens—he even sketched out the interior of the UFO. His renderings were the inspiration for this pattern.

⊟ PATTERN COLOR SWATCHES

Psychotronic_p1 Psychotronic_p2 Psychotronic_p3

⊞ TILED PATTERN

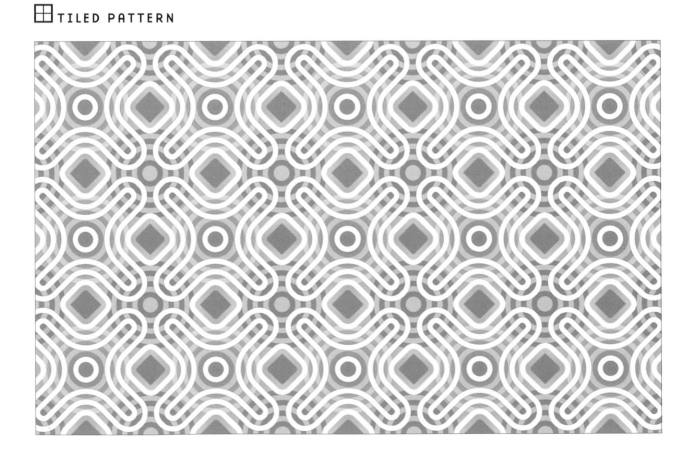

95

EMBLEMATIC

Princess Grace meets Ozzy Osbourne. This pattern is elegance with an edge.

▣ PATTERN COLOR SWATCHES

Emblematic_p1 Emblematic_p2 Emblematic_p3

⊞ TILED PATTERN

DOUBLE DUTCH

This pattern is quaint and delicate, like faded teacups from a lowland antique shop.

⊟ PATTERN COLOR SWATCHES

Double Dutch_p1

Double Dutch_p2

Double Dutch_p3

⊞ TILED PATTERN

Denise Gallagher

Illustrator
Louisiana, USA

www.denisegallagher.com

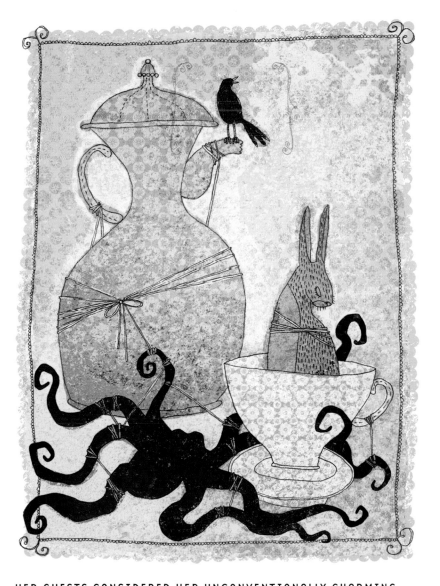

HER GUESTS CONSIDERED HER UNCONVENTIONALLY CHARMING.
Artwork created by Denise Gallagher. Copyright © 2008.

DESCRIPTION

The pattern Double Dutch reminds me of fragile, tinkling teacups, lace doilies and tiny cakes arranged just so. It inspired me to sketch—imagining a charming and unique hostess. What would one do, I mused, if while balancing a teacup and thinking of the perfect thing to say, a miniature octopus was spied curled among the cakes and tea? I was pleased with the outcome—a teapot, a teacup and an octopus, all tied up with string.

My drawing came to life as I began painting in layers of color in Photoshop—vintage browns, dusty blue and blood red. Time-worn textures created the feeling of a dimly lit parlor crowded with china and tiny creatures hiding in its corners.

I used the Double Dutch pattern—beat up and tinted to match—as a background as well as to fill the teapot and teacup to the brim. It added the perfect air of mystery and charm to the vision it had inspired.

—Denise Gallagher

97

TI WICKER

This is space-age rattan—made of titanium wicker. Glossy, rust-proof
and guaranteed to maintain its shape even in a meteor shower.

 PATTERN COLOR SWATCHES

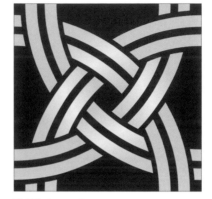

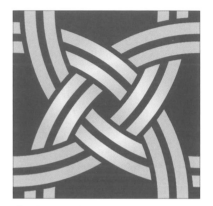

Ti Wicker_p1

Ti Wicker_p2

Ti Wicker_p3

⊞ TILED PATTERN

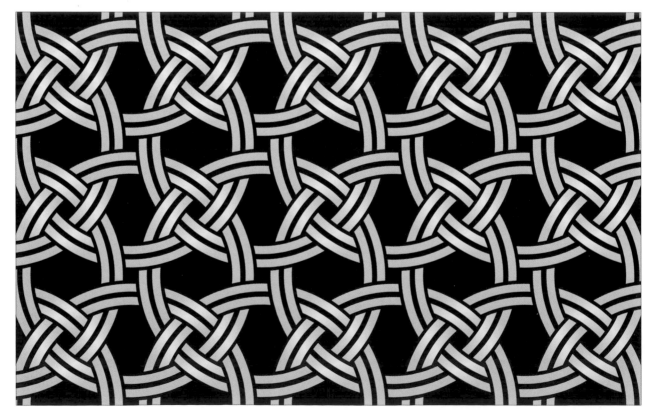

BRICK HOUSE

Marketing wolves may try to huff and puff and blow your concept down,
but with this pattern, you'll stand firm against the winds of ignorance.

▤ PATTERN COLOR SWATCHES

Brick House_p1

Brick House_p2

Brick House_p3

⊞ TILED PATTERN

SERENGETI

Derived from the Maasai word for "endless plains," the Serengeti provides a rich backdrop to the planet's largest migration. Join the herd and embrace the wild kingdom that is design.

 PATTERN COLOR SWATCHES

Serengeti_p1

Serengeti_p2

Serengeti_p3

⊞ TILED PATTERN

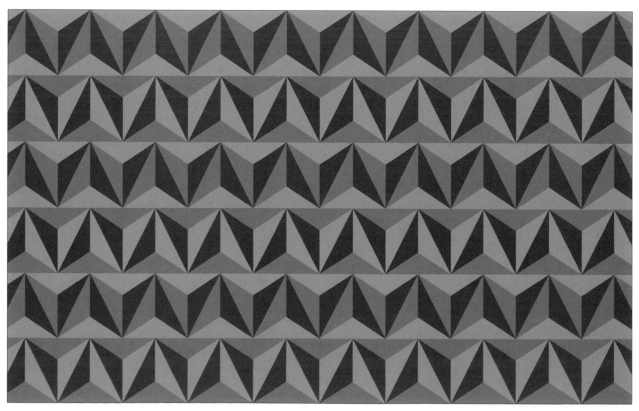

GARDEN GATE

A willowy wire-framed gate encloses a garden of patterned possibilities.
Viva verdant vectors!

▤ PATTERN COLOR SWATCHES

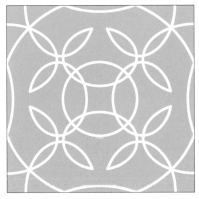

Garden Gate_p1 Garden Gate_p2 Garden Gate_p3

▦ TILED PATTERN

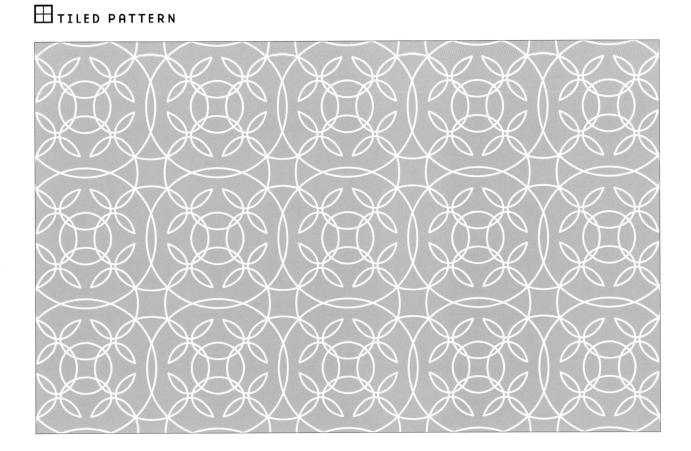

CONTINUUM

Space/time glitches can disrupt your senses, but this reality-bending
pattern will help you meet those intergalactic deadlines—no wormhole
travel necessary. Designed by Paul Howalt.

▤ PATTERN COLOR SWATCHES

Continuum_p1 Continuum_p2 Continuum_p3

▦ TILED PATTERN

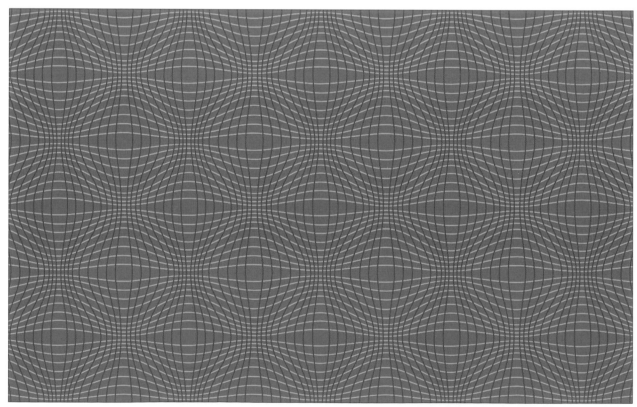

PALATIUM

Whether it's Park Avenue, Paris or Portland, this classy motif adds
sophistication to your next haute project. Palatium is Latin for "a palace,"
one of seven hills in Rome where aristocrats built large homes.

⊟ PATTERN COLOR SWATCHES

Palatium_p1

Palatium_p2

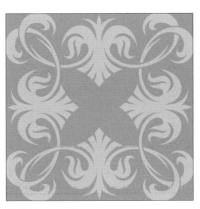

Palatium_p3

⊞ TILED PATTERN

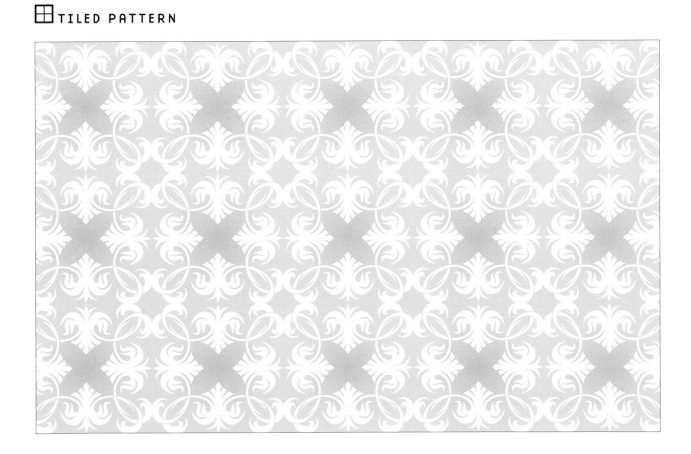

MOROCCAN TAPESTRY

During my first visit to Israel, I spotted this elaborate motif at a Moroccan restaurant. It speaks of spicy, fragrant dishes, crowded souks in old cities and hand-knotted rugs sold by mint-tea-sipping vendors.

 PATTERN COLOR SWATCHES

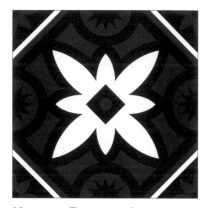

Moroccan Tapestry_p1

Moroccan Tapestry_p2

Moroccan Tapestry_p3

TILED PATTERN

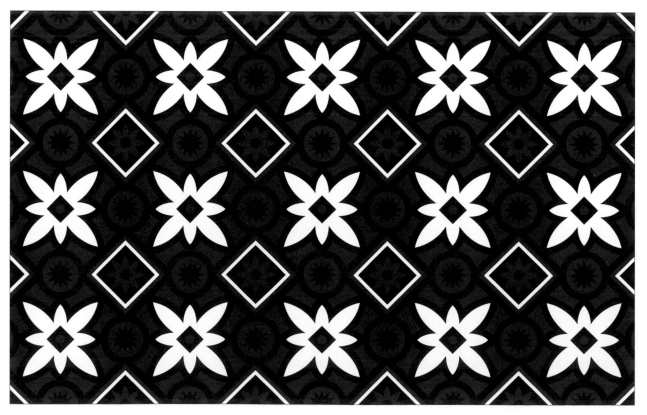

TREE FORT

Childhood memory: It turned out the area I built the tree fort on was private property. The unhappy landowner asked for my name. I said, "Uh...Jimmy Wilson." Now if Jimmy would have invited me to his birthday party, I would have used another name. This event was the inspiration for this pattern. Designed by Paul Howalt.

⊟ PATTERN COLOR SWATCHES

Tree Fort_p1 Tree Fort_p2 Tree Fort_p3

⊞ TILED PATTERN

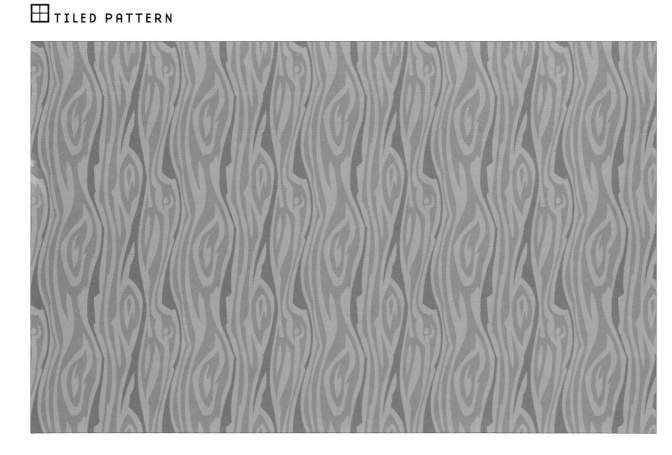

INDEX OF CONTRIBUTORS

Part of the bonus set found on the DVD only.